NUNEATON

STREET BY STREET

THROUGH TIME

Peter Lee

AMBERLEY PUBLISHING

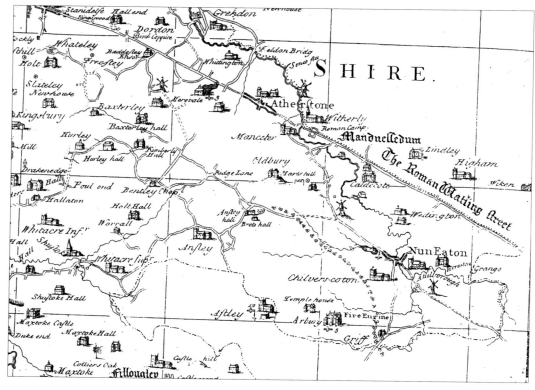

Map of Nuneaton, 1725.

Dedicated to the participants in the Nuneaton Local History Group. A group of enthusiasts interested in old Nuneaton, and all those people who have expressed a desire to learn more about their own home district over many years of mutual correspondence.

First published 2012

Amberley Publishing
The Hill, Stroud, Gloucestershire, GL5 4EP
www.amberley-books.com

ISBN 978 1 4456 0659 0 (print)

British Library Cataloguing in Publication Data.
A catalogue record for this book is available from the
British Library.

Typesetting by Amberley Publishing.
Printed in Great Britain.

Introduction

In order to prepare the next selection of photographs for your entertainment, I decided to look at the ancient core of the town and parish of Nuneaton, and its layout of ancient streets for which the pattern had been set centuries before the great expansion that started at the end of the 1800s. In the early nineteenth century Nuneaton was little more than a village. It had one main street, Abbey Street, which was about a mile long terminating at Abbey End. Other ancient streets were Church Street as far as Church End; Bond Street, which terminated at Bond End; Coventry Street, which led to Chilvers Coton Parish (Coton Road); and two perimeter lanes: Back Lane, and Derby Lane, which led into Brick Kiln Lane (now Regent Street). In addition, a few roads led off, terminating in the middle of fields, and later stopped up by railway lines – Wheat Street, Oaston Road, and Meadow Street. The main roads out of town still fell within the ancient curtelage of the parish: Attleborough Road, Wash Lane (now Queen's Road) Arbury Lane, Coton Road, Swan Lane, Haunchwood Road, Hinckley Road, Derby Lane leading into Weddington Lane. As well as these we will examine in a bit more detail the streets and buildings of the outlying communities close by. Not to forget the Market Place of course, which played a pivotal role in town life and still does today. Nuneaton Market draws people in from miles around. It is the modern town's biggest tourist attraction.

Acknowledgements

I would like to thank the following who have generously contributed photographs from their collections, assisted with my research, or who have been very supportive over many years:

Beryl Kerby, Jean Lapworth, Geoff Edmands, Madge Edmands, Maurice Billington, Ian and Tom Burgoyne, Alan Cook, Moreton J. Ensor, Dennis Labrum, Ray Smith, Craig Langman, John Burton, David Sidwell, Steve Casey, Fred Phillips, Reg Bull, Anne Gore, Hilda Oliver, Arthur Tooby, Reg Rowley, Gay Parker, Phillip Vernon, Victor Welland, Dean Elliott, Michael Roberts, Michael J. Lee, Peter Bayly, Keith Draper, Norman Raisen, Harry Cawthorne, Pat Boucher, John and Celia Parton, Celia Hornbuckle, *The Nuneaton News*, the *Coventry Evening Telegraph*, Nuneaton Library, Coventry City Libraries, Warwickshire County Records Office, Leicestershire County Records Office, Birmingham Reference Library, Nuneaton Local History Group, the committee of the Nuneaton & North Warwickshire Family History Society and people living in the town who still have 'Old Nuneaton' at heart.

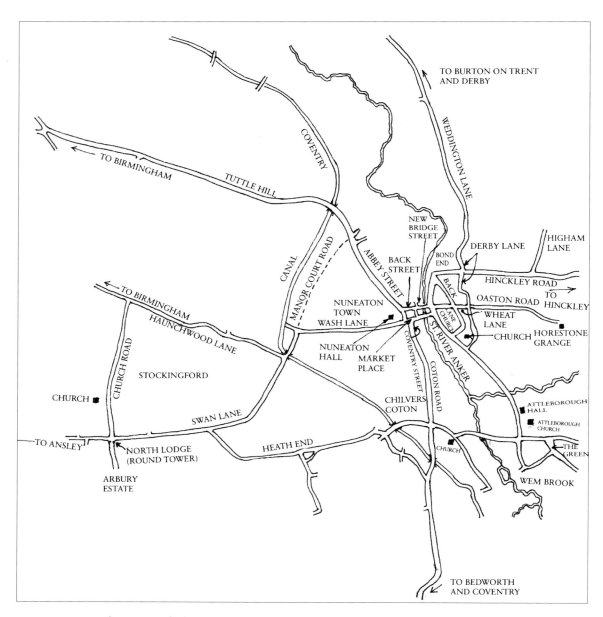

Street Map of Nuneaton before 1840.

Abbey Street

Until the nineteenth century the principal street in Nuneaton was Abbey Street. With the local population of the town at around 8,000, two thirds of that population lived in Abbey Street. It was overcrowded and congested with former long back gardens built over and turned into courts and tenements. These courts were squalid, insanitary and damp. Daylight was limited by the closeness of the buildings, which were often fully enclosed with windows on one side only looking out onto a scruffy yard. In other towns 'courts' were known as 'yards'. Perhaps there was one-upmanship in Nuneaton. We called them courts, which gave them a kind of dignity, but they were just as filthy as yards elsewhere. To add to the general dirt and disease these courts accommodated vegetable patches, pig pens, and deep cesspools. When Abbey Street was first laid out it was built for the best people in Nuneaton: Abbey retainers, tradesmen, and town officials. There were good, timber-framed front houses fringing the street and long narrow gardens. With the Reformation, and the general decline in the status of the town, these houses were converted into shops, and later many became pubs and beer houses. The owners built tenements to obtain more rent. Some were rebuilt as top shops with their large windows to let in plenty of daylight to illuminate the work of the silk weavers. In the early years of the nineteenth century the principal trade of the town was silk weaving. Two thirds of the local population were either wholly engaged in making silk ribbons, or to some extent dependent upon it. Most of these lived in Abbey Street. Abbey Street provided a significant part of the properties which were progressively pulled down between 1935 and 1956, condemned as unfit to live in. During that period 1,051 slum houses were demolished.

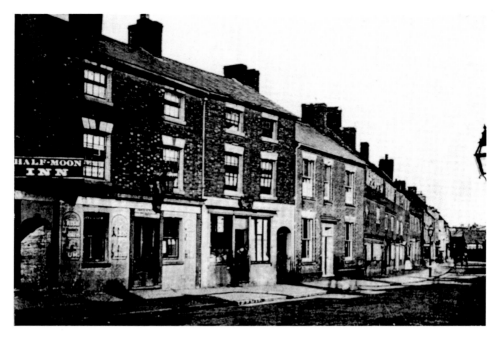

Abbey Street around 1880. This view is towards the town centre, to the right of the Half Moon Inn, and the shop is what was termed 'a good front house', which had secreted away at the back one of the many courts where our ancestors lived in poor conditions, as did all the buildings in this roadway. To the right of that house is a row of 'top shop' weavers' cottages, which would soon be swept away as this part of Abbey Street was rebuilt in the 1890s. (Tom Burgoyne collection)

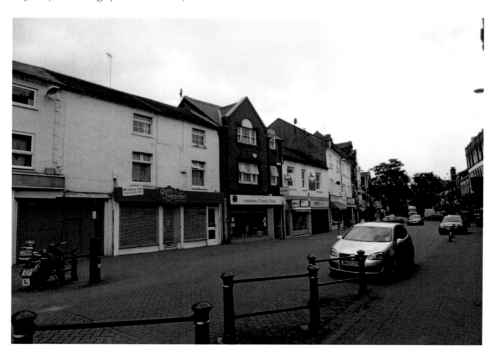

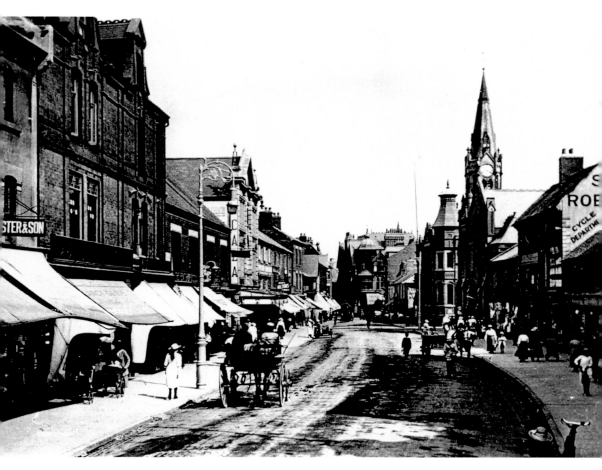

This gives a more general view of Abbey Street from an elevated position *c.* 1910. The street has changed enormously from the 1880 view. Back then it seemed quiet, but in this view the town is all bustle. (Author's collection)

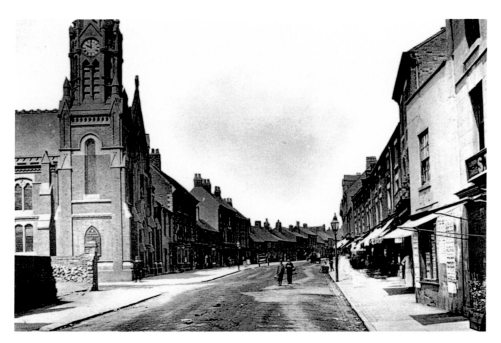

The corner of Abbey Street with Stratford Street off to the left. The tall spire of the Wesleyan Methodist church stands on the opposite corner. Today the former Liberal club building is located where the broken wall is, and it seems likely the wall has been part-demolished in preparation for building the club. The open area behind the wall was known as Till's Yard. Rowland Till (1814–92) was licensee of the Pheasant pub in Abbey Street, a few yards behind the camera to the left, and he also carried on his trade as a blacksmith. Mr Till also let his yard out for Nuneaton's May Day celebrations every year when roundabouts, swings, hobby horses and various fairground attractions brought out the local population for a much-needed good time. The town lock-up had been erected close to here in 1823, but when Stratford Street was put through in 1859, a new police station and lock-up was built in the new street. (Brian Millington collection)

Although this view from the 1970s is familiar to us today, most of the left-hand side of the road has long been demolished. In front of the bulk of the Ritz cinema on the right-hand side is the Wellington Inn. Beyond that the gable end of the Coach and Horses (later called the Kingsholme), soon to be demolished and replaced by a petrol station. (Maurice Billington)

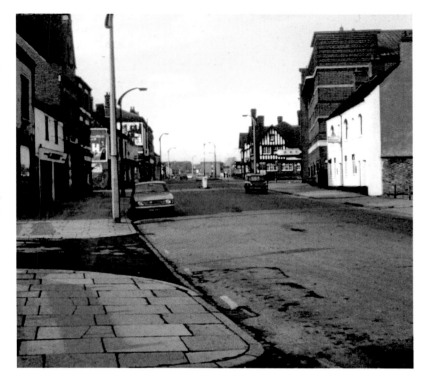

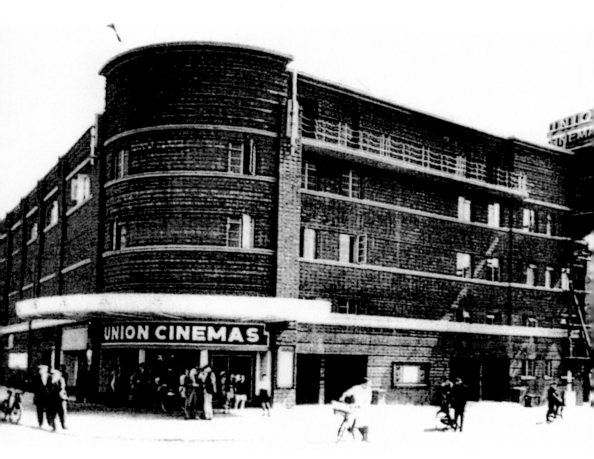

I hope that by the time this book is available the Ritz cinema will be on its way back to being a cinema again so that the magic of a good night out at the 'flicks' can be reprised. It was opened in 1937 by Union Cinemas and became known as the Ritz in 1939. The Saturday matinees were a particular memory for thousands of local kids who flocked there to marvel at the adventures of Zorro, Superman, Davy Crockett, Popeye, dozens of 'Cowboys and Indians' films, as well as a mixed bag of pretty poor science-fiction B-movies. We knew no better of course and a couple of hours of thrilling kiddie entertainment could be topped off with a delicious hot sausage or pork 'batch' dipped in gravy over at 'Picken's Batch Bar' across the road. (We call batches baps or bread rolls today in case anyone is wondering!) How many times did I wander home with gravy dribbled down my clean Saturday matinee shirt! (Courtesy of Victor Welland)

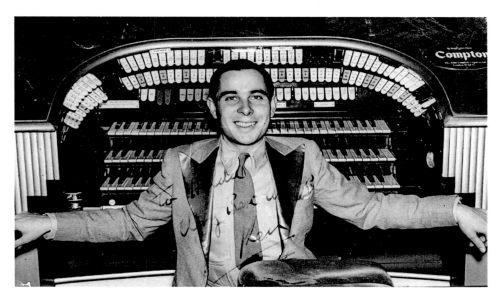

The Ritz had a glorious Compton organ which rose out of a pit in the stage and heralded the start of a blockbuster film. Here is Ken Stroud, master organist, possibly some time in the 1940s. The organ was later sold to a church in Essex where it can still be heard today. (Hilda Oliver collection)

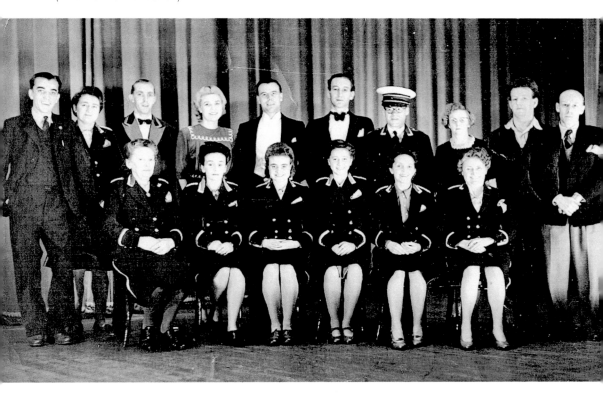

The Ritz staff, 1947, in all their finest uniforms. Their attractive attire made going to the cinema such a grand occasion. (Hilda Oliver collection)

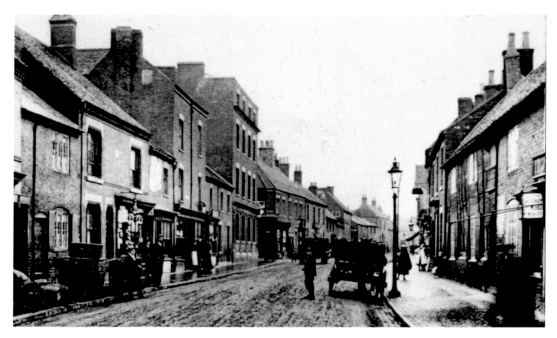

Walking along Abbey Street around the year 1909 we come to Upper Abbey Street, which started at the next block behind the tall four-storey building in the centre of the picture. This building was erected as a warehouse for the silk ribbon trade at the height of the gauze ribbon boom. After the slump that followed it was converted in the best Nuneaton tradition, into a pub – The Gauze Hall – by the 1840s and later it became a Baptist chapel. A new Baptist church opened in Manor Court Road and the Gauze Hall closed for worship in 1899. The building was taken over by Alexander Lorimer in 1901 and turned into a hosiery factory. It traded as Poole Lorimer and Taberer until 1928 when the whole lot went up in flames in one of the biggest fires Nuneaton folk had witnessed up until that date. By 1930 demolition started along Abbey Street because many of the courts and houses seen here were deemed unfit to live in. These early evacuees from Abbey Street were moved to new council houses at Hill Top and Stockingford. (Reg Bull collection)

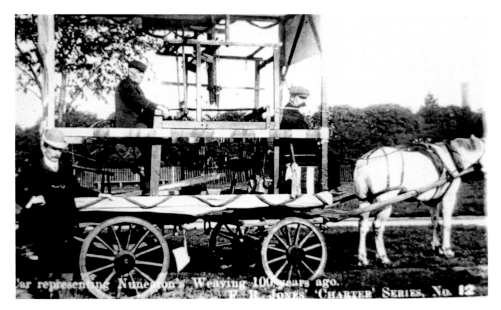

A trade synonymous with Abbey Street, and much of old Nuneaton was celebrated in Nuneaton Charter Day celebrations of 1907. Here one of the last old hand looms is wheeled out and paraded through the town in recognition of the silk trade's important part in local life at the beginning of the nineteenth century. Most if not all of these old looms were broken up for the timber or used as firewood. (Author's collection)

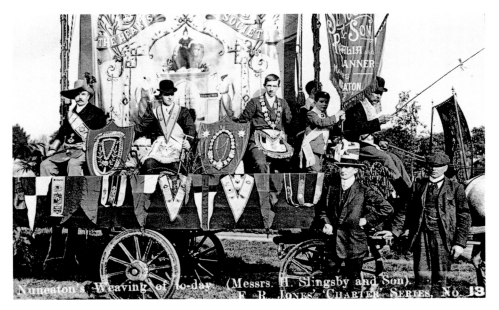

The silk ribbon trade in Nuneaton did survive. H. Slingsby & Son specialised in regalia, medal ribbons and banners. This is their float in the 1907 carnival celebrations at Nuneaton recreation ground. Slingsby's business was founded in 1843 at a time when the silk trade was in terminal decline and by introducing this new line of silk goods they triumphed against the odds. The company survived until the 1940s. (Author's collection)

In a photograph taken in the late 1950s we are coming to the end of the demolition phase in Abbey Street. We can, in fact, see three pubs in this view, and a fourth which is a pub no longer. A white building in the far distance in the centre of the road was formerly a pub but by this time was an outdoor beer licence. To its left is the Oddfellows Arms, which took its name from the Friendly Society that met there. Latterly it was called the 'Oddies'. The blank gable end to left of centre is the end wall of the Wheatsheaf, which would subsequently be replaced by a new pub on the opposite side of Priory Street. The old Wheatsheaf was demolished in 1963. Nearer the picture is the Royal Oak, just about to be pulled down. The Royal Oak was not replaced as a pub.

Back Lane/Back Street

We often get confused today by just where Back Lane is or was. A little bit of the inner ring road known as Back Street exists currently between the corner of Bond Street and Leicester Road. This was formerly called Back Lane, but the lane continued some distance along Vicarage Street until it joined Attleborough Road. This was all Back Lane. The name Vicarage Street did not exist at the beginning of the nineteenth century. Back Street used to run at the back of the Market Place in a short stretch from Abbey Gate at the bottom of Abbey Street to Newdigate Square. It was called Back Street because it was at the back of the Market Place.

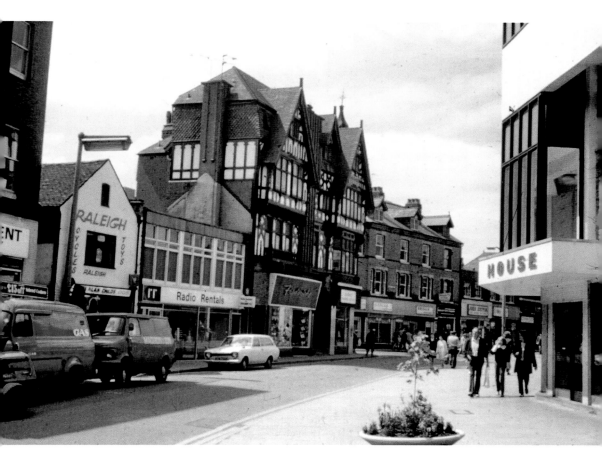

Although we think of this as Newdigate Street today, in fact it should be Back Street, and the Back Street that is now should be Back Lane. Confused? I am not surprised. (Peter Bayly)

Bond End

The origin of the name Bond End (or Bond Street as it we now call it) has never been satisfactorily established beyond the thought that it was here the people in the town were bound to the Lord of the Manor by some kind of serfdom. Serfdom died out in the Middle Ages and somehow the Bond(ed) end of town remained. Whether that attribution of the name is true or not I cannot say, but this explanation seems to be the one put forward by local historians in previous generations. It was the ancient way out of town towards Weddington Road, but not the original way to Hinckley. The ancient roadway to Hinckley was on a different alignment to the one we use now along Hinckley Road and the Long Shoot. The old Hinckley roadway left the town via Wheat Street, Horestone Grange and across the fields to Dodwells Bridge. Its close alignment in Wheat Street/Oaston Road is still there, but when you get to the Horestone Grange housing estate and beyond the trackway is lost. I assume the removal of the old road took place when Francis Stratford (1705–62), then Lord of the Manor, enclosed the Horestone Grange fields around 1735 and pushed the roadway out to the perimeter of the enclosed fields, to what we now know as the Long Shoot (a long narrow field) and Hinckley Road.

Returning to Bond End, this was the old entrance/exit to the town. The roadway was built up and widened in the sixteenth century to reduce flooding. If you look at it carefully you can still see that it is wider than our normal old town thoroughfares due to ancient civil engineering work. In 1847 the Trent Valley Railway was opened, which blocked Bond End with a level crossing used to let road traffic through. Unfortunately there were quite a few deaths at this spot because local people often circumvented the barriers to spring across in front of trains. The parish council clamoured for the railway company to bridge the line and make it safer to cross. They did eventually agree to this and Leicester Road Bridge was erected in the early 1870s. The Bond End crossing could then be dispensed with and the former exit to Hinckley Road blocked.

In the early 1870s a siding from the railway trailed down Bond End and entered John Knowles, flour mill premises in Bridge Street (where Debenhams is now). Known locally as the Flour Mill Tramway, it caused no end of trouble in its brief life. In tramway fashion it was first laid with rail track flush with the road surface, and later on Mr Knowles re-laid part of it with a new larger section rail which was proud of the surface. At least one horse had to be put down because it tripped over it and broke its leg, others had less serious injuries. The local population found it hazardous too. After a flurry of complaints Mr Knowles was forced to abandon the tramway and remove the track. Why he did not simply relay it with lighter track flush with the surface seems lost to history. Perhaps the cost of replacement was too high?

Modern residents in Nuneaton will be familiar with this part of Bond End as it looked in the 1880s. The pub to the right of the picture, The Railway Tavern, is still there and hardly altered. For many years it was owned by the Marklew family and I guess it was opened at the same time as the Trent Valley Railway in 1847. The old pub premises on the left, The Crown, have been entirely replaced today. At one time there was a court of cottages at the back called Crown Yard with a skittle alley attached. (Tom Burgoyne collection)

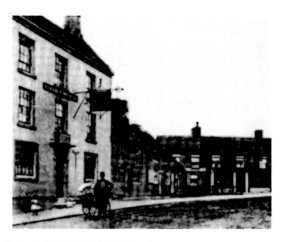

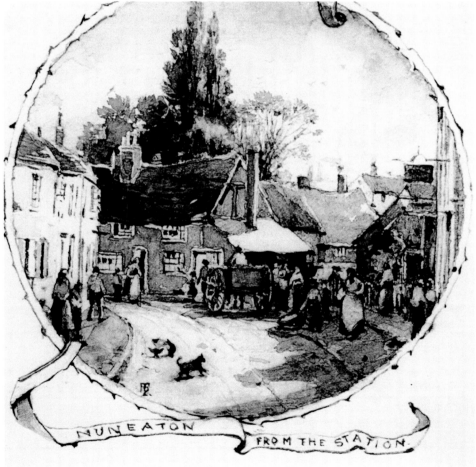

Pattie Townsend, the well-known local watercolourist, has captured the view looking down Bond End away from the station in the 1870s. The Crown Inn is on the extreme right. The approach to Nuneaton looks very picturesque in this old image.

This old print illustrates the very first railway station in Bond End. A smart set of picturesque buildings were erected when the Trent Valley Railway opened in 1847 in a style described as Jacobean. A much larger and finer example still exists at Atherstone, although the Nuneaton station was swept away in the 1870s as rail traffic grew and new junctions were installed. The growth of rail traffic after 1870 was phenomenal. A third station was built in 1913 and replaced the second one. The 1913 station survives today and now has seven platforms. Rail traffic through Nuneaton station is brisker than ever! (Author's collection)

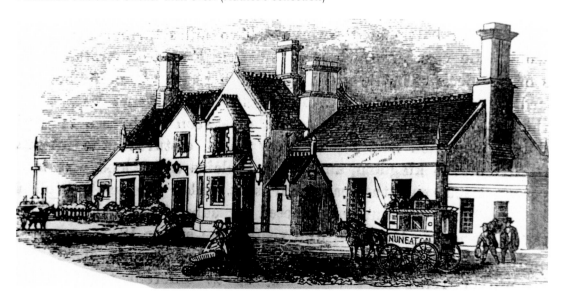

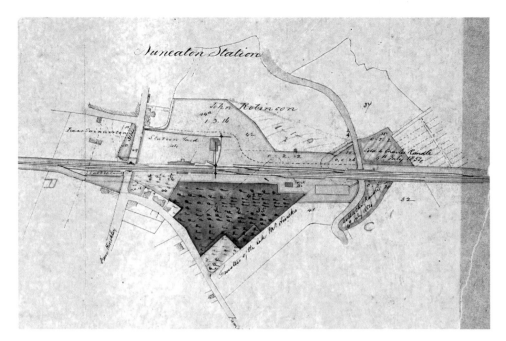

An original 1847 plan view of the first Nuneaton station (the one in the previous print) shows the first layout and modest faculties. The station itself had just two platforms then. Most of this area would be built over with a large goods and marshalling yard swallowing up the rural idyll of the original station. (Peter Lee collection)

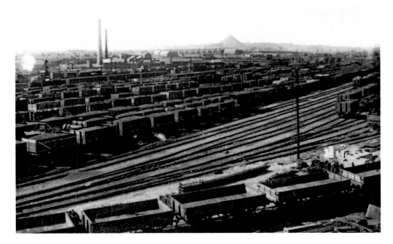

By the 1940s Nuneaton had become a massive freight centre. This is the marshalling yard with coal, the dominant freight, ready for despatch all over the country. The original open station site was swallowed up by these developments in the period 1873–1930. The south end yard or the marshalling yard is in the foreground. The north end goods yard is beyond, with the distinctive conical tip of Judkins Quarry dominating the high ground. This view would be impossible to take today as it was photographed from the top of the tank house, a water tank which fed the water columns in Nuneaton marshalling yards. The brick base formed a cosy albeit noisy railwayman's cottage occupied by yard staff.

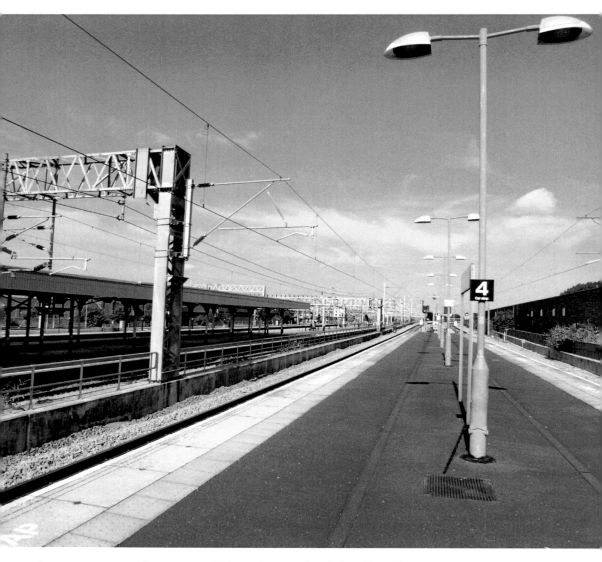

In 2012 a new set of passenger platforms have replaced the old goods yard, which spread from the main station on the left all the way across to way back beyond the warehouses on the right. The shriek of whistles, the clatter of buffers, the shouts, and ding-ding of hump shunters' warning bells, could be heard day and night at this point.

Brick Kiln Lane

At one time part of Regent Street, that section between Leicester Road Bridge and Wheat Street, was called Brick Kiln Lane. There was a brickyard about halfway along it, roughly where Cooper Street is today but extending back over the Trent Valley Railway line. The construction of the TVR obliterated the old brickyard, and the roadway was altered by the railway. At one time there was a clay hole on the corner of what is now Regent Street, but was then Brick Kiln Lane, which went by the name 'Lord Hop's Pit'. It received its unusual name from an association with Francis Stratford of nearby Horestone Grange mentioned earlier. Francis Stratford was given the nickname 'Lord Hop' by the local population who knew him when he frequented the bar of the Bull Inn (now the George Eliot Hotel) and it is said drank rather too much. (The full story of 'Lord Hop' is so far-fetched it lies outside the scope of this book.)

The Trent Valley Railway cut a swathe through the town and altered all the streets. What is now Regent Street was originally called Brick Kiln Lane because there was a brickyard right in the centre. By the time this photograph was taken in the early 1960s there was no sign of it. The railway had obliterated it entirely. The houses on the right are at the end of Wheat Street. Where they end there was once a level crossing, which was all that was needed originally when there were two tracks. By the 1870s two level crossings in close proximity was a disadvantage to both the local population and the railway company so the Leicester Road Bridge was erected. This photograph was taken from the Leicester Road Bridge looking south towards Rugby. The large warehouse building on the left was originally built as a silk ribbon weaving factory and stood in Oaston Road. It ended its days as a railway warehouse and was heavily vandalised then burnt out. The warehouse was demolished a few years after this photograph was taken.

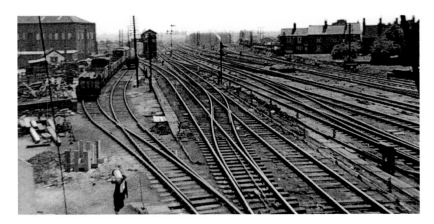

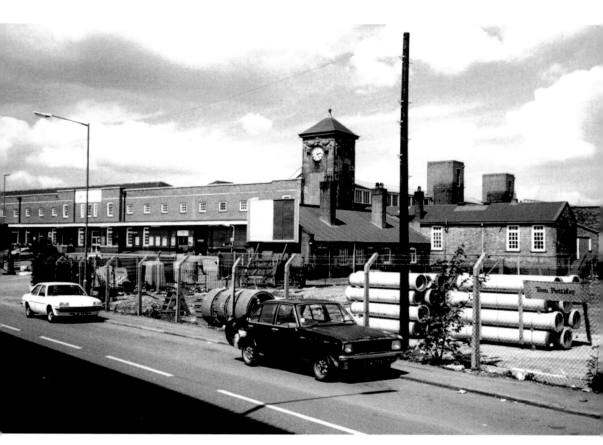

This is a complicated picture to describe regarding its early layout because although we know the roadway today as Regent Street, entering onto Bond Street where the station stands, it was at one time called Brick Kiln Lane and Derby Lane, and was radically altered by the coming of the railway. Derby Lane ran into Brick Kiln Lane somewhere around where those pipes are stacked. In 1988, when this picture was taken, the former Nuneaton Timber Co. yard had been demolished and new retail warehouses were just about to be erected. Brick Kiln Lane forms the current Regent Street and terminated at a junction with Wheat Street. Next to where the white car is parked was an old pub, The Dun Cow, said to be the most haunted pub in Nuneaton. It was demolished in 1845. (Author's collection)

Turning my camera around in 1988 from the earlier view, where Derby Lane entered Brick Kiln Lane, you can see the roadway of the former lane now transformed into Regent Street. It crested the rise up to the Leicester Road Bridge. (Author's collection)

Bridge Street

The principal bridge over the River Anker was at one time in Bridge Street. In effect up until the nineteenth century it was the only road bridge over the river. The blue-brick bridge erected in what is now Newdigate Street was not built until the early nineteenth century because at that point the river was forded and there was a wooden footbridge for foot traffic. To confuse matters, part of Bridge Street (which was longer then than it is now) was called Silver Street; at least it was so known up until the 1830s. The part with this name was from the bridge to the Market Place. The extremity of the Silver Street was later marked by the old post office, the one demolished in 1912. The post office buildings were demolished and the Market Place extended backwards to get more space. The Market Place then entered Bridge Street adjacent to what is now the George Eliot Hotel, formerly the Bull Hotel. At one time a small charge was extracted from market traders bringing their produce to market over the bridge, which went into the coffers of the Abbey. This toll was known as 'Pontage', and was to be towards the maintenance of the bridge to keep it under repair. The toll ceased when the Abbey was closed down by Henry VIII.

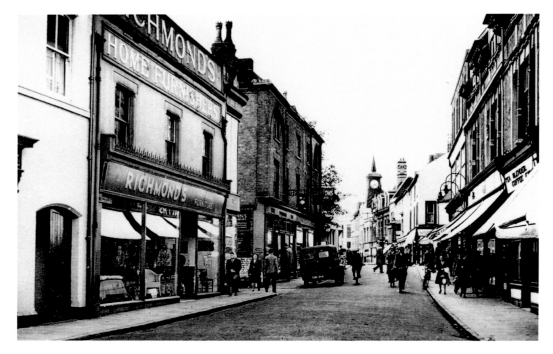

There are many old views of the Old Bridge Street and the roadway provided a dignified but restricted entrance to the town. Bridge Street was widened in 1959. (Geoff Edmands collection)

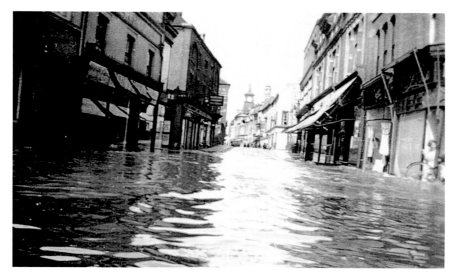

A view quite similar to the one on on the previous page but at the height of the 1932 flood. The top of the bridge is dry but water has poured along Bridge Street from Mill Lane and along Bond Gate. (Tom Burgoyne collection)

This modern view belies the activity that goes on when market day is on. Debenhams is on the right. Although the street has been pedestrianised and tidied up, it has lost its character.

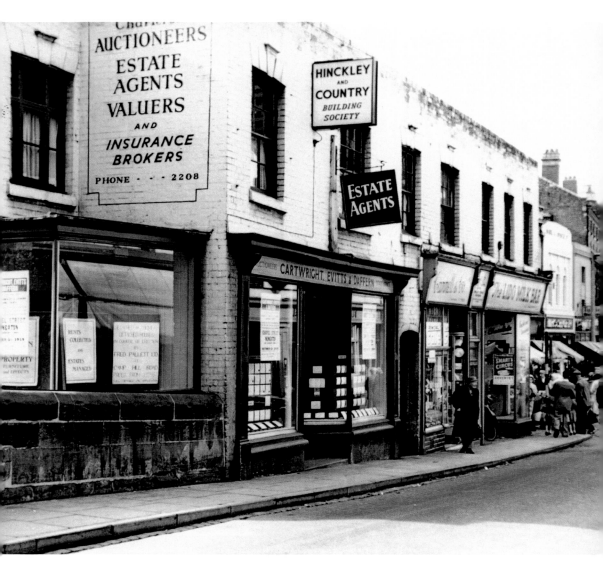

A close-up view of the shops leading into the Market Place from Bridge Street with the stone parapet of the bridge on the left. This row of shops included the well-known 'Milk Bar' on the right. At one time (until the 1830s at least) this section of the approach to the town bridge was called Silver Street. (Reg Bull)

The town bridge has disappeared beneath modern shops, but the slope of the road gives an indication that there is a bridge here somewhere.

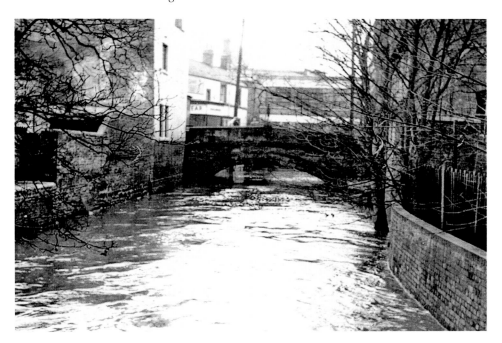

The River Anker in full spate through the bridge in Bridge Street shows how a flash flood can turn into a deluge through the town centre as a huge body of water is forced into this narrow gap. The flow of the river was much reduced due to a flood relief scheme constructed in the 1970s, which allows increased volumes of storm water to bypass the town. The reduction in water flow seems to have encouraged the growth of shrubs and trees in the narrow gap approaching the town bridge. (Geoff Edmands)

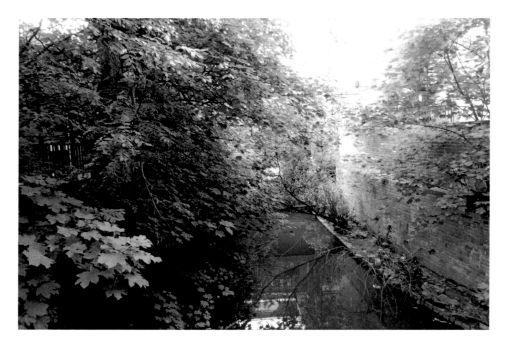

The River Anker today in a more placid mood. Its days of breaking its banks are hopefully gone forever.

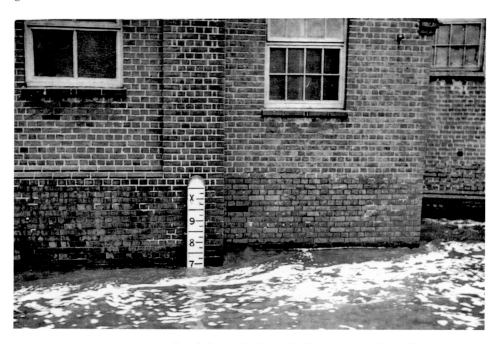

At one time a water gauge was fitted alongside the wall of the flour mill in Mill Walk. When water reached X local people moved their furniture, carpets and pets upstairs, put their wellies on, rolled their trouser legs or hitched their skirts up. Kids made the most of it, but many shops lost their stock. (Geoff Edmands)

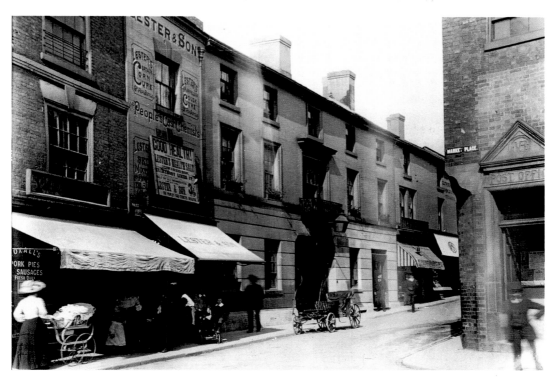

Above: Every year that goes by we see changes to familiar buildings, and the Bull Hotel, which is very familiar to us today as the George Eliot Hotel, was originally a coaching inn used by more than one line of mail coaches, as it was the principal stop on the route between Coventry and Leicester. The narrow entrance to Bridge Street shows the old post office on the corner. George Eliot immortalised this pub as the Red Lion in 'Janet's Repentance' in *Scenes of Clerical Life*.

Right: A closer view of the Bull entrance, *c.* 1907. There was stabling for horses at one time, and an old blind beggar used to scrape away a tune on a violin by the gate to cadge a few coppers from hotel guests and passersby for his supper. (Author's collection)

Church Street

This was the oldest and most posh street in the town at one time, where the local gentry lived. As its name implied it ended at the parish church. Church Street was laid out when Nuneaton, then known as 'Eaton' (Water Town) was first occupied as a settlement, probably before the Norman Conquest. It stood on a piece of high ground above the river and was on a trackway which passed through the great Forest of Arden to the Roman Watling Street. In those days Eaton was secluded and hidden from most inhabitants of the country; just one street including a small church, a watermill, and a few open fields giving a modest living to a few farmers and their families. When the Abbey was established Church Street was superseded as the principle street of the town by Abbey Street. Eaton became 'Nun-Eaton' (denoting its new Abbey status, which was predominately run by nuns at the time of its founding). Growth in the area of the town took place on the opposite side of the River Anker to Church Street.

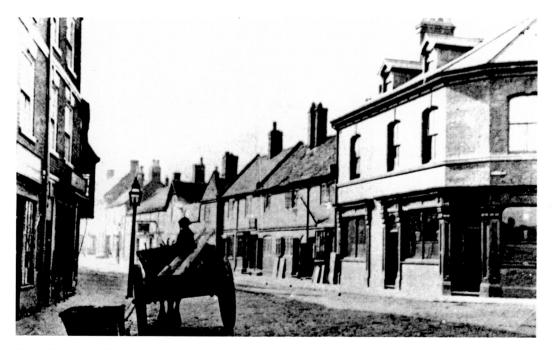

This old view of Church Street looking towards Church End with Bridge Street on the right probably dates back to the 1880s. There are two pubs in this view: the Marquis of Granby on the corner, which had recently been rebuilt, and a little further up on the right The Queen's Head, whose pub sign can be seen immediately to the right of the gas lamppost. The Queen's Head was later rebuilt as the pub we knew as the Pen & Wig back in the '70s, and is now Reflex. (Author's collection)

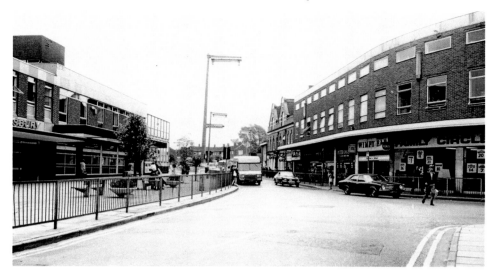

A similar view but over ninety years later in 1973. The car is turning into Bridge Street, which had not been pedestrianised. The Queen's Head has become the Pen & Wig, and on the left all the old properties have gone. In fact everything has changed. (*Coventry Evening Telegraph*)

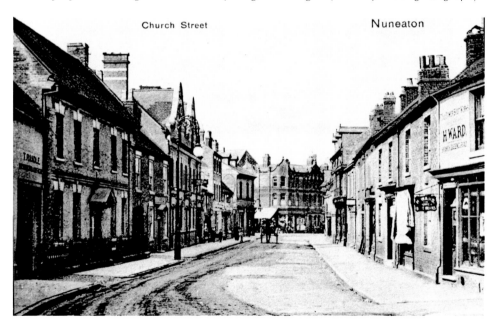

An old picture postcard view of Church Street *c.* 1905 leads us towards the corner of Bridge Street and is full of old buildings. The gateway on the left once led through to Mill Walk. The opening is still there, but today it is a proper road. Immediately beyond that is Mr Pettifer's house, originally owned by John Robinson, maltster and blue-brick maker, friends of Mary Ann Evans (George Eliot's family). The distinctive gable ends of The Queen's Head are still there today. The building near the horse and buggy on the left of the picture is another pub, The Marquis of Granby, which we saw earlier. Virtually everything you see here has been demolished or altered beyond recognition. The townscape was more interesting then.

Church Street is a shadow of its former self. In May 1941 the Luftwaffe badly damaged all the properties on the left, although they could have been saved. But post-war they did not have the money to rebuild. The bomb damaged a row of eighteenth-century houses, including Lawyer Dempster's House, and they were demolished. Today the 1960s block of government offices on the right stands empty and to let.

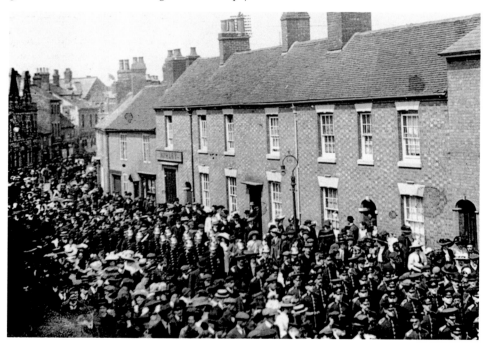

Church Street in 1910, and a parade in remembrance of the late King Edward VII. The view was taken close to the junction of Church Street and Vicarage Street. (Maurice Billington collection)

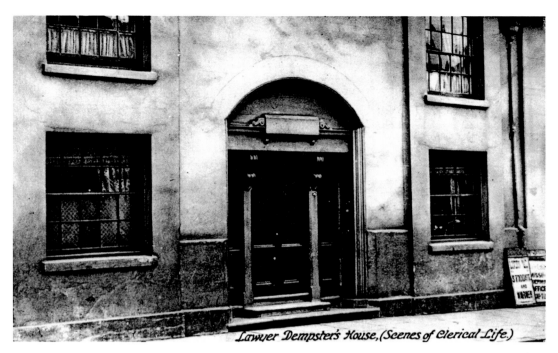

Lawyer Dempster's House, (Scenes of Clerical Life.)

George Eliot (1819–80) knew Church Street, Nuneaton, very well as she attended The Elms, a private school close by, between 1828 and 1832. This house was named after a lawyer with whom she was familiar. 'Lawyer Dempster' was modelled on, it is said, James Williams Buchanan (1792–1846), a local lawyer who had some notoriety at the time.

These wooden shops replaced the old houses that were once a feature of old Church Street. With town centre developments underway even these will succumb shortly as this area of town is redeveloped.

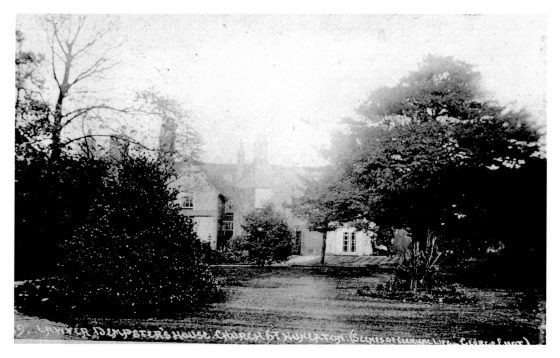

The rear of Lawyer Dempster's House in Church Street. These gardens still exist in part as part of the George Eliot Gardens. The house itself was badly damaged on the night of the great German raid on Nuneaton on 16/17 May 1941 and was demolished just after the war. However, the open aspect of the garden has been preserved. (Peter Lee collection)

The same garden today. Just visible above the hedge is the roofline of the timber shops fronting Church Street.

The former Mill Gardens, later renamed the George Eliot Gardens, with the former rear garden of Lawyer Dempster's House on the right beyond the wall. The old flour mill is on the left. The picture dates back to the mid-1950s. (Author's collection)

Speight. Nuneaton. 30.

MILBY.

(NUNEATON CHURCH).

"Few places could present a more brilliant show than might be seen issuing from Milby Church. There were the four tall Miss Pittmans, old Lawyer Pittmans daughters, with cannon curls surmounted by large hats, and long drooping ostrich feathers of parrot green." There was Miss Landor, the Belle of Milby, clad regally in purple and ermine, with a plume of feathers neither drooping nor erect but maintaining a discreet medium." Scenes of Clerical Life. (Chap. 2).

Many people in nineteenth-century Nuneaton knew who George Eliot had written about. They had been familiar with the gossip of the day portrayed in *Scenes of Clerical Life*.

It was a great pity that the local authority and English Heritage allowed the church to build a car park on George Eliot's historic churchyard, full of old Nuneaton characters. I would have thought that the last bastion of old Nuneaton's historical townscape would be sacrosanct from the infestation of the motorcar, but it was not to be. Hundreds of people protested but the church entirely ignored their requests and lobbied to build the car park for several years. It would have seemed logical to me to ask the local authority to give churchgoers dispensation to waive charges in the half-empty council car parks next door on a Sunday in order to preserve this last bit of old Nuneaton.

Coventry Street

This was (and is) a very short street which led off the Market Place towards Chilvers Coton. Its length was determined by the bridge over the Wash Brook where Coventry Street abruptly stopped and the road became Coton Lane (now Coton Road). The border of the parishes of Nuneaton and Chilvers Coton ran through the brook at this point. From a Chilvers Coton perspective this point was one of the four 'ends' of the village – Town End. The other Chilvers Coton ends were Church End, Heath End and Virgins End. Coventry Street had been very narrow until it was considerably widened in 1928.

Derby Lane

As the name implies this roadway once extended to Derby. In the nineteenth century it was a complete stretch of the imagination that this dusty lane might end up in the industrial town of Derby, which seemed a very long way away in those days. Derby Lane entered Nuneaton along what is now Weddington Lane, which came into a T-junction with Hinckley Road where the former Graziers pub used to stand. Derby Lane did not end there. Before the Trent Valley Railway was built it did a dog-leg and Derby Lane continued along what is now Regent Street to where Leicester Road Bridge intersects and terminated there. Derby Lane is now in effect Weddington Road and Weddington Terrace.

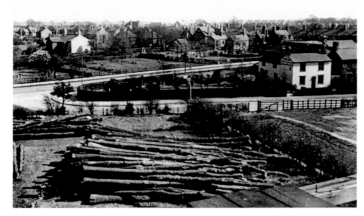

There is a degree of difficulty in obtaining the correct elevation to take a modern-day equivalent of this picture, but it shows a timber storage yard where below there is a builders' merchants storage yard with Weddington Terrace (formerly Derby Lane) and the relatively new Weddington Road beyond. Both roadways are still there but much has changed. (Author's Collection)

A short stretch of Derby Lane remains, albeit called Weddington Terrace. Weddington Road lies beyond the junction. It is hard to imagine this is the main road to Derby but it was. There are no exact views to hand of this stretch in the old days.

A glimpse of Derby Lane or Weddington Terrace can be seen from platforms 6 and 7 at Nuneaton Station.

Hinckley Road

As the name implies, Hinckley Road led out of town towards Hinckley, but I believe the alignment we know today is only 300 years old. I mentioned that this road alignment was not used until Francis Stratford (1705–62), who owned the manor of Nuneaton, enclosed his fields in 1730 and pushed out the old roadway to the periphery of his Horestone fields.

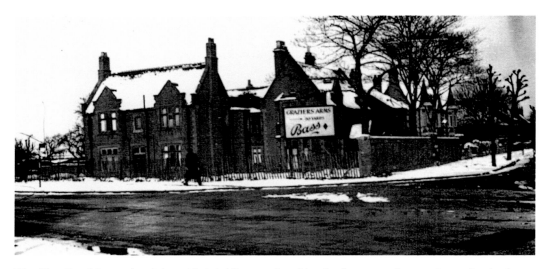

Hinckley Road is on the right with Weddington Road in the foreground one wintry day back in the '40s. The houses prominent in the picture were swept away and a BP garage now stands on this site.

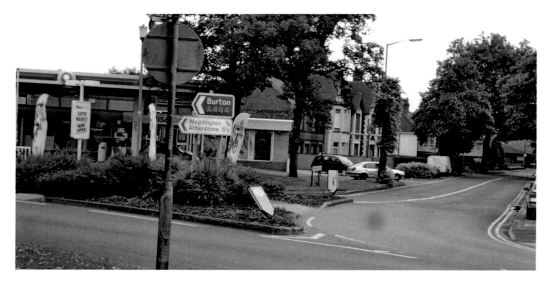

Manor Court Road

Manor Court Road has been established for centuries. There has been a roadway from the top of Queen's Road (by the Cock & Bear pub) to the top of Abbey Street at Abbey End since time immemorial. Effectively this was little more than a cart track used as a short cut and for carrying coal from the Stockingford collieries to the Abbey end of town. The through road was disrupted for several months in 1811 when a small bridge, which took the Manor Court Road over the Wash Brook, was swept away in a flood. There was a clamour to have it reinstated because of the long diversion people had to take to get into Abbey Street via Wash Lane and the town centre. If you look at the map today you can see it was a long way round and the Manor Court Road was an ideal shorter route. As the nineteenth century progressed and the town's population increased Manor Court Road was progressively laid out, and a wide boulevard was formed from 1878 when the road was widened to 30 feet with extensive houses and villas erected along it. It became Nuneaton's best address for many years. The remains of the old Abbey were found in the fields either side of the road. After the Dissolution, the Abbey was left to decay and the gaunt, rotting buildings and stonework were taken away by locals intent on using the abandoned buildings as a convenient source of building materials for their properties elsewhere in the town. As late as 1913, chunks of carved stone identifiable from the Abbey were discovered in old properties in Abbey Street then being demolished.

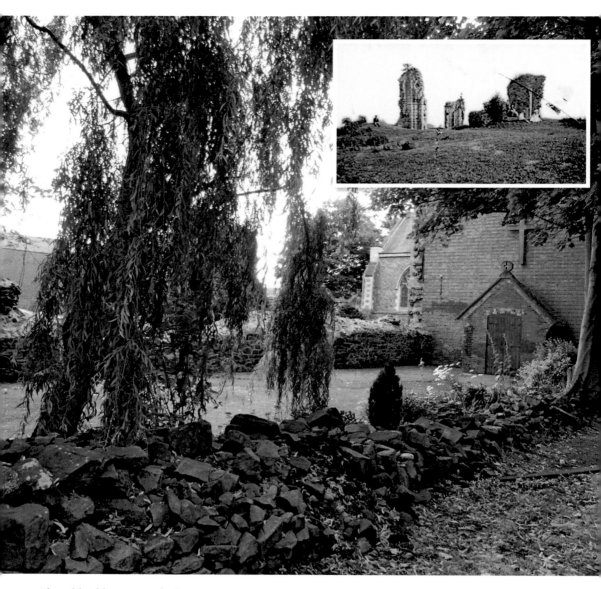

The old Abbey ruins before reconstruction commenced in the 1870s (inset). Parts of these columns were incorporated into the new church. It was a popular picnic spot at the time. (Author's collection)

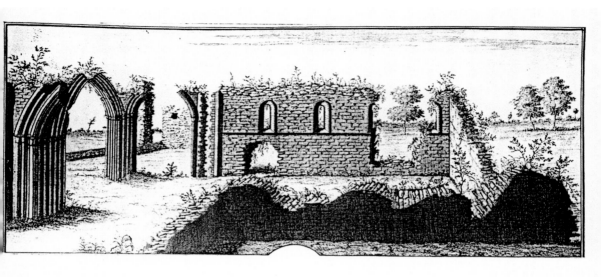

Nuneaton Priory ruins, 1729. (From an engraving by S. & N. Buck)

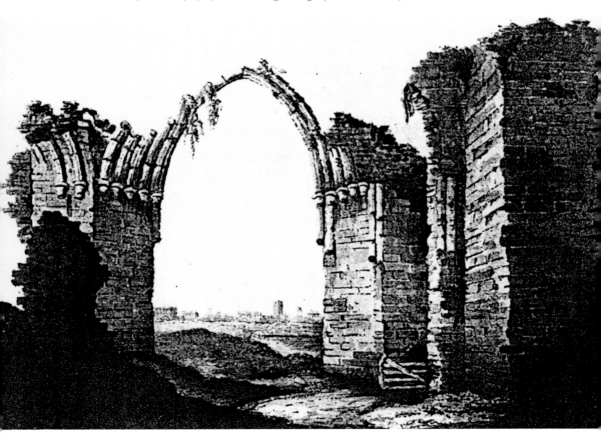

Nuneaton Priory ruins, *c.* 1820. (From a drawing in the Aylesford collection)

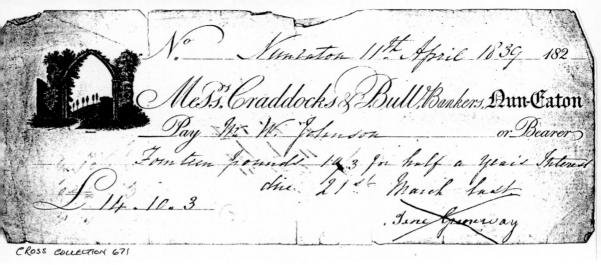

Nuneaton folk were very proud of their Abbey ruins at one time, even to the point of incorporating illustrations of them on their local bank cheques. Craddock & Bull's bank was the lineal corporate ancestor of today's Barclays Bank.

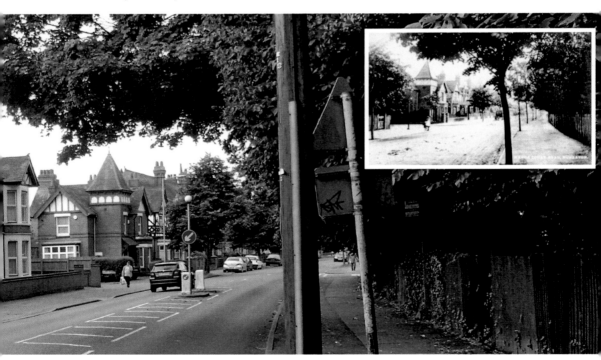

Above and opposite: Manor Court Road, a wide boulevard lined with young trees. (Author's collection)

Inset: Manor Court Road was widened to 30 feet in 1878 and large building plots afforded the opportunity to erect large villas such as those on the left-hand side in this view. (Author's collection)

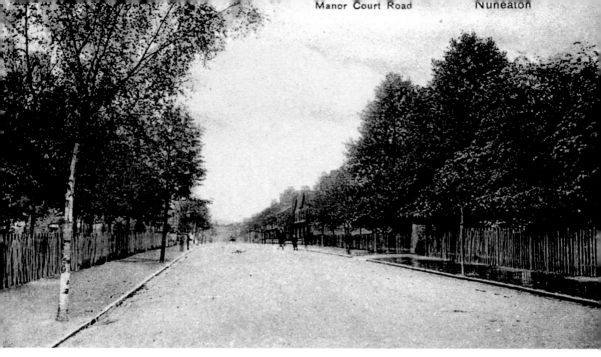

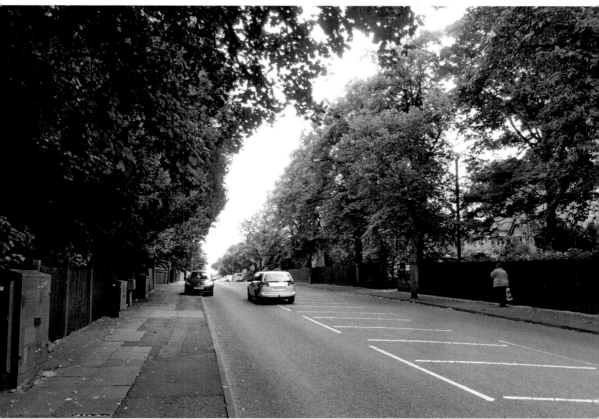

Market Place

Church Street was the principal street in ancient times until the Norman Conquest. The owner of the manor of Nuneaton, Robert Earl of Leicester, established a daughter house of the great Abbey of Fontevrault in the fields across from the town around the year 1153. Where the edge of the Abbey grounds reached towards the River Anker they stamped their financial authority on the community by establishing a weekly market in 1226, which served to provide a source of steady income from market tolls and charges on market traders. At one time a Market Cross stood in the centre of the Market Place and served as an office to collect these taxes. A set of wooden stocks were erected so that miscreants could be publicly humiliated by having their heads and arms tethered to be spat at, urinated on, beaten and smeared with anything the local unwashed population felt was appropriate. All this amidst the clamour of a busy market area with wooden stalls, butchers' shambles and some semi-permanent sheds, which regular traders used for selling their wares. Cattle, sheep and pigs were herded into the Market Place to be butchered on the spot. Frightened animals would often make a break for it, overturning stalls and baskets of vegetables, trampling people, and running amok before they could be captured and killed. They were cut up there and then before the eyes of the local market goers. The Market Place over 300 years ago was a crude and frightening place to our twenty-first-century eyes. Close to the Market Place, between here and Stratford Street, there stood a substantial house which is believed to have been the Abbot's house or Habit. By the seventeenth century this mansion boasted ten hearths, and was about the size of Horestone Grange over the fields towards Hinckley. Both properties were owned by the Stratford family in the seventeenth century. It is not surprising that the Abbot would want to live close to the Market Place when this was the point where a large part of the income for the Abbey was being generated. Not so far to transfer the cash; better than having to cart it over the open meadowland to the Abbey itself. After the Reformation the large house or habit passed to the Lords of the Manor, and in the 1660s it was used by the Stratford family as a Dower House. This is how Stratford Street got its name. The new roadway was built on the garden of the hall, on a piece of ground known as Hall Gardens when the street was laid out in the 1850s. The hall fell into disrepair in the eighteenth century and was a complete ruin around the turn of the nineteenth century when it was demolished.

Probably by the seventeenth century a number of stallholders in the market used permanent wooden sheds, which clustered in the range of buildings that today stretch back from the Market Place to Newdigate Street. Over the years these wooden sheds and stalls were superseded by brick structures, so that by the early nineteenth century the block was a rabbit warren of jitties and passageways interspersed with permanent

shops and some public houses. At one end of this block, on the corner of Newdigate Square, butchers gathered and established a shambles. Amongst the Shambles there was also an old pub known as the Plough. The Shambles consisted of lean-to sheds fronting the streets where animals were slaughtered on market day. Imagine sitting in the dust and gloom of the old Plough Inn, enclosed by the Shambles, with its array of clay pipes strung along the fireplace for use by anyone who fancied a pipe of tobacco washed down with a gallon of ale amidst the bloodcurdling screams of pigs, sheep and cattle being put to death just next door; their warm blood pooling on to the cobble stones in the entranceway for you to slip on as you wobbled unsteadily out of the door onto the street. That is how it was in the Old Market Place in the good old days.

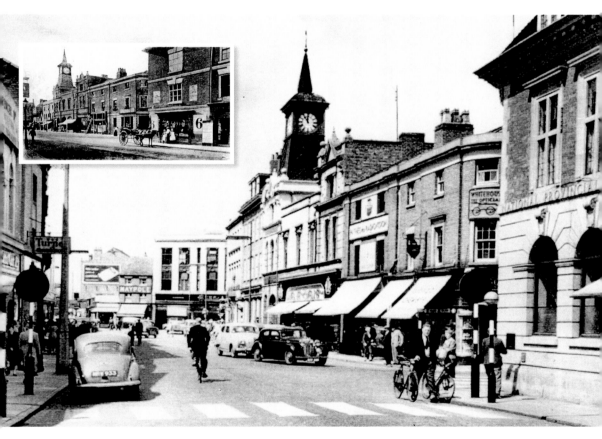

This is a similar view taken in the 1950s. At one time in the 1960s Nuneaton's famous town-centre clock was threatened with demolition, but a clamour of objections saved it, and it was modernised by installing an electric motor. (Author's collection)

Inset: The Market Place in the period 1901–09. The butchers' shambles once occupied the corner behind the horse buggy, in the block occupied by Iliffe's the chemist when this photograph was taken. The former Plough Inn had stood on the corner. (Author's collection)

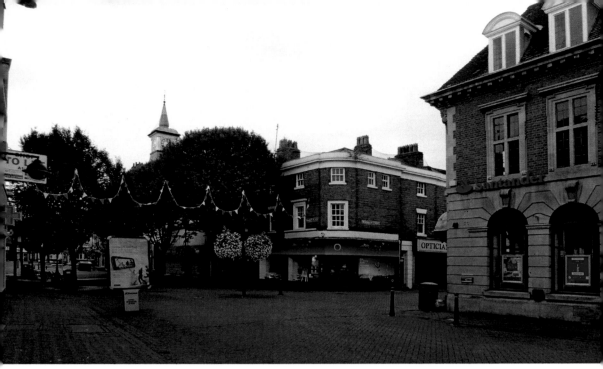

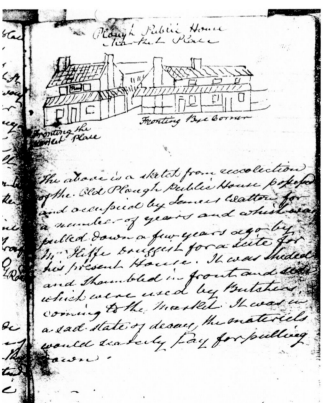

This drawing shows how the Old Plough looked up until its demolition *c.* 1840. The sketch was made by the Nuneaton diarist John Astley who kept a diary of town life between 1810 and 1845. The diary is fascinating; full of scurrilous local gossip. It was saved from being torn up by Alfred Lester Scrivener (1845–86) when it was brought into his office in Abbey Street by an old lady while he was the first editor of the *Nuneaton Observer*. The first serialisation of the diaries occurred in the *Nuneaton Observer* during the late 1870s. Alfred Scrivener enlarged on its background in his newspaper columns and the document remains an intimate insight into town life at the beginning of the nineteenth century.

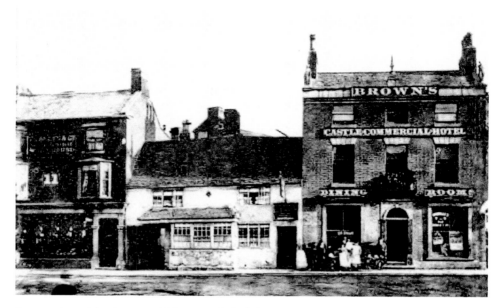

At one time this view would have included three pubs, but by around 1880 it had been reduced to two. Francks boot and shoe emporium on the left replaced an ancient pub, the Old Ram (extant in 1544), demolished in the 1870s. The pub in the centre is the White Hart, a meeting place for local radicals. Obviously a very old hostelry too. On the right is the Castle Commercial Hotel, opened in October 1817. By this time (*c.* 1880) it was owned by Ebenezer Brown (1828–1905) who became one of the wealthiest men in Nuneaton through his investments in the pub trade. (Author's collection)

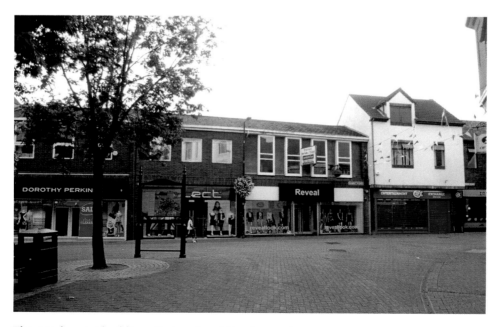

The nondescript buildings that replaced the three pubs.

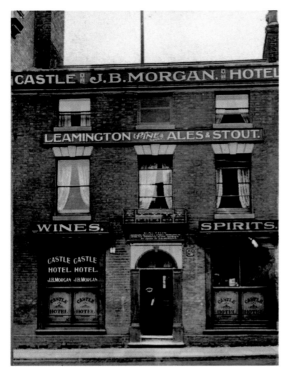

At some time prior to 1912, James Birt Morgan took over the Castle. A miner by trade, he had travelled up to the Midlands with his brother Edmund from the Forest of Dean. Edmund became a brewer in Tamworth, whilst after a spell as under-manager at Charity Colliery, Bedworth, James took over the Peacock in the Market Place, before the Castle became available. He acquired the Castle and turned it into a thriving commercial success. He died in 1920 aged fifty-nine. The Castle was demolished around 1965. (Courtesy of Nita Pearson)

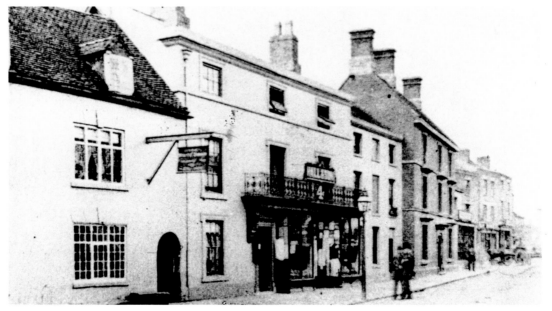

The Market Place was a locality dominated by public houses and inns, with eleven licensed premises either in the Market Place or just off. Here on the left is the White Swan, closed in 1962. Beyond is Hall & Son, drapers. The building slightly back from the frontage line is Smith's Charity School. The dominant building beyond is the former banking premises of Craddock & Bull's. Later to become Barclay's Bank as we know it today. (Author's collection)

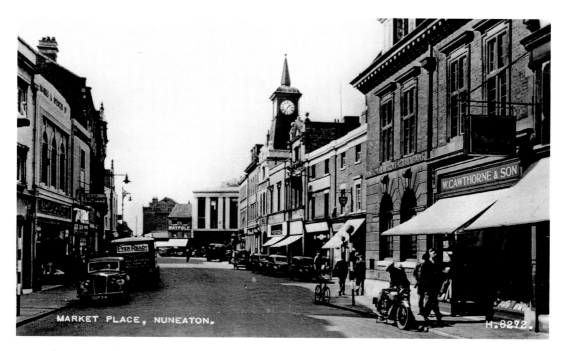

The Market Place in its heyday in the 1940s, and how many old timers remember it. Although this is not a market day, people are going about their business. There are a wide variety of styles of architecture, which made the old town so attractive.

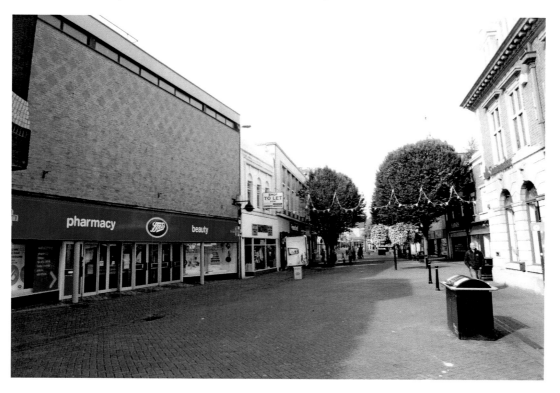

Some years ago Nuneatonians were excited to find this old building exposed after the demolition of buildings fronting the Market Place and Queen's Road. Rumours swirled around that it was, in fact, Nuneaton's original treacle factory, and that was how Nuneaton earned its well-known nickname, 'Treacletown'. But our hopes were dashed when we discovered that it was in actuality a former provender store for a long-defunct company selling animal feed. The well-known local business Ryder-Betts Ltd used it for a time. Latterly it had been used by a local greengrocer for storage. But we did manage to see inside it. The excavated ground in front was where Nuneaton Hall stood. This was demolished around 1800 and last used as far as we can tell as a dower house for the Stratford family. Although no real archaeological excavations took place when this opportunity arose, at least one local archaeologist carried out a bit of investigation. (Norman Raisen)

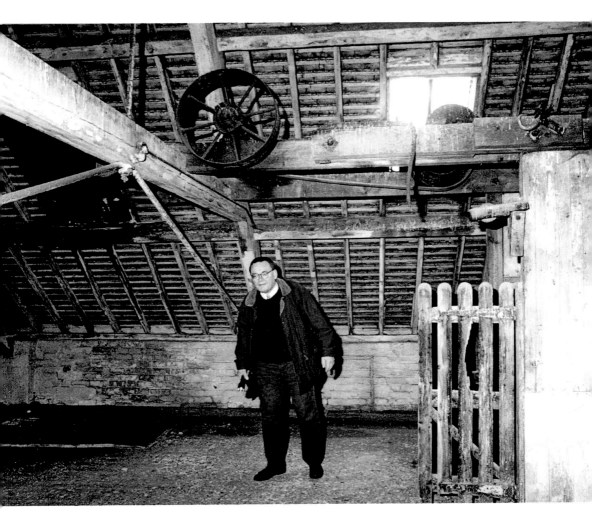

This is the top floor; pretty damp but intact with its rusty hoist. My good friend the late Councillor Harry Cawthorne is in the photograph. Harry accompanied me and Norman Raisen on this mission. The hoist was used to haul bags of animal feed through the floors for storage, but it had been disused for many years. The building is still there today but has been swallowed up by the rebuilding that had started when the old building was revealed.

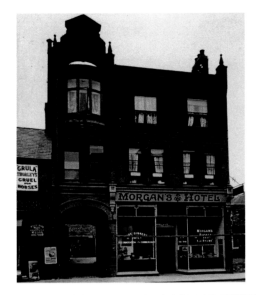

For many years the building that obscured the old provender store shown in the previous view in Queen's Road (which can just be glimpsed through the gateway) was Morgan's Hotel and dining rooms. The Morgan is question was John Birt Morgan, who owned the Castle Inn in the Market Place. I would imagine accommodation here at the time was primitive, but adequate for travelling salesmen and for visitors to the town.

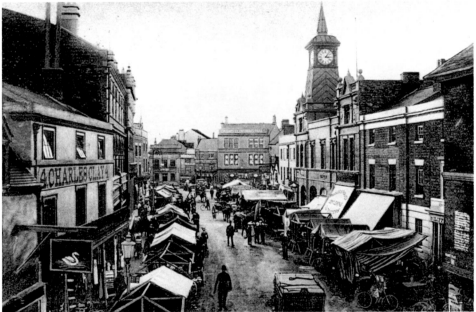

It would need a mechanical platform to reproduce this picture today from the same position, but the view here was taken from an upstairs window in the old post office, which dates it earlier than 1912. The building on the extreme right was knocked down and replaced in 1909, so it must have been between 1901 and 1909. It depicts market day, which even today is Nuneaton's biggest tourist attraction. There are no other visitor attractions like this one. The market brings in people from a wide distance, and with the advent of the car people now travel from much further away than they used to. I knew one fellow who regularly came from Solihull to shop in Nuneaton Market. In the far distance are a range of buildings, all now replaced, including the Crystal Palace on the left, demolished in 1909, whose smoke room we shall see next. (Author's collection)

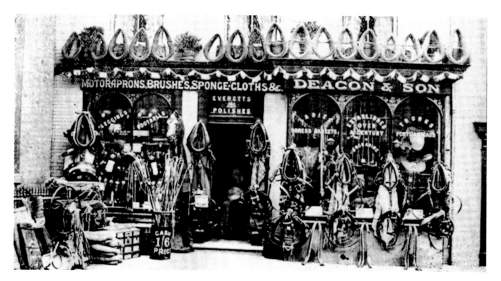

Just imagine putting this lot out every morning and taking it in at night. Deacon & Sons' business was started in 1798 by George Gray (1776–1857). George Deacon (1850–1926) carried on the business until his death. The location of Deacon's today by contrast is a bland-looking piece of architecture if you know where to look.

The site of Deacon's saddlery has been tidied up since the old shop closed in 1926.

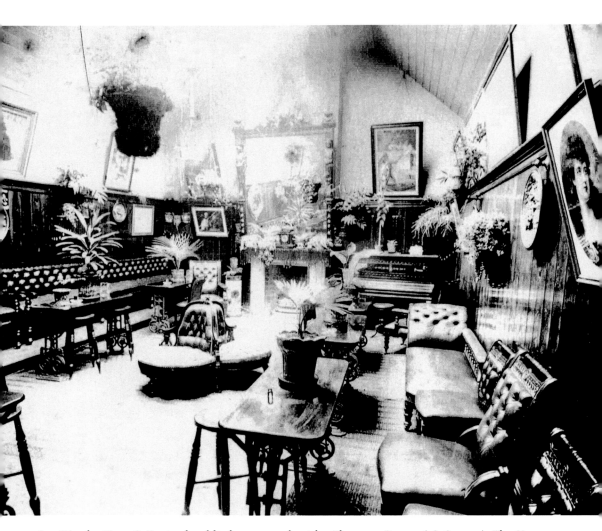

In 1863 the Hare & Squirrel public house was kept by Ebenezer Brown (1828–1905). The Hare & Squirrel appears to be his first venture. In 1871 he renamed it the Crystal Palace, which was probably due to a large, multi-faceted crystal ball that he installed, hanging from the ceiling, which glistened and sparkled to such an extent that our Nuneaton ancestors, not having witnessed anything like it before, must have been fascinated and bedazzled by it: the Victorian equivalent of a laser light show. Sometimes we are incapable of grasping the lack of social and leisure opportunities our ancestors had in 1871. Some years later the licence was taken by Mr Frederick Charles Wrighton (1843–95). Following Mr Wrighton's death in 1895, a newspaper report in the *Nuneaton Chronicle* 1896 read, 'Mrs Wrighton has opened her new Smoke Room with Lunch Bar as a Bohemian Lunch Club at the Crystal Palace.' So, from the look of it this is the new smoke room, where our ancestors loved to hear their landlady sing, and enjoy all the other contemporary acts of the day. You can imagine seeing it through a fog of smoke from pipes and cigarettes, packed with our venerable ancestors noisily enjoying a great night out in downtown old Nuneaton. (David Floyd)

Meadow Street

There were no streets that broke the traditional street pattern of Nuneaton and encroached on the Abbey site up until the mid-nineteenth century save Meadow Street. Certainly by the 1840s it led off Abbey Street at right angles and serviced a development of cottages erected on the former Abbey Meadow.

Newdigate Square

In the nineteenth century this was called Bye Corner (or sometimes called Pye Corner) and was a curious dog-leg in the road leading to Abbey Street and into a roadway that led to the river. In 1844 the river was bridged and the roadway then became New Bridge Street, the name being changed later to Newdigate Street. Later the square of Bye Corner was changed to Newdigate Square.

The dominant feature of Newdigate Square was the old Newdegate Arms Hotel. Parts dated back to the sixteenth century if not earlier. The hotel also doubled as a court of law well into the nineteenth century and had a large sports ground for cricket, athletics, football and horse events. The hotel was owned latterly by Mr T. J. Lilley (1862–1921) and he was offered £8,000 by the local council for the piece of ground projecting into the road so that the building could be demolished for road widening. For this reason the hotel was rebuilt in 1914, clearing away this jumble of old buildings to get a bit of space for the motorcar. But the First World War intervened, which slowed the job down considerably.

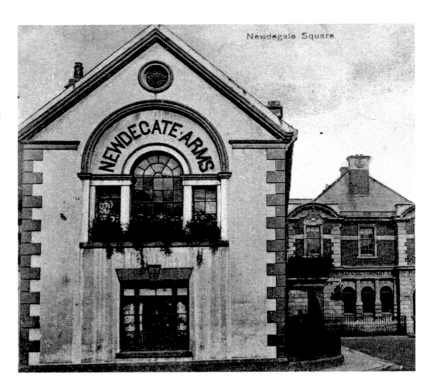

The original Newdegate Arms Hotel. Mr Lilley had the replacement Newdegate Hotel built to the rear of these premises but increased raw material costs and delays through lack of labour due to skilled building workers having answered the call to arms caused Mr Lilley a great deal of financial difficulty. He sold the new hotel to Bass & Co. and moved to take up the license of the Hollybush. (Author's collection)

Below: The hotel that replaced the old Newdegate Arms during the First World War was magnificent, but it only lasted forty-odd years. Here is seen a detail of its splendour before demolition in the early '60s. (Reg Bull)

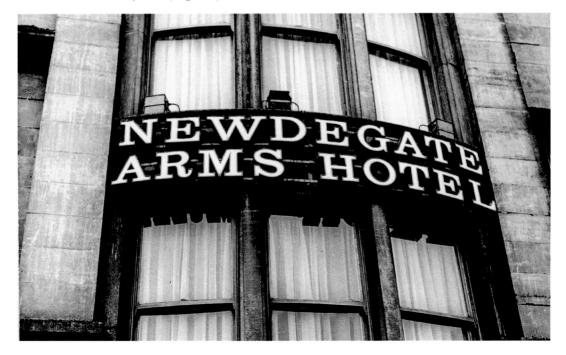

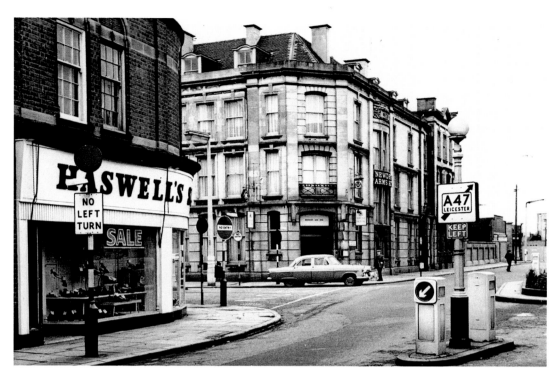

The replacement Newdegate Arms which should never have been demolished. Today it would have been an asset to the town. The replacement block of buildings was supposed to have included a hotel but there were no takers. (Reg Bull)

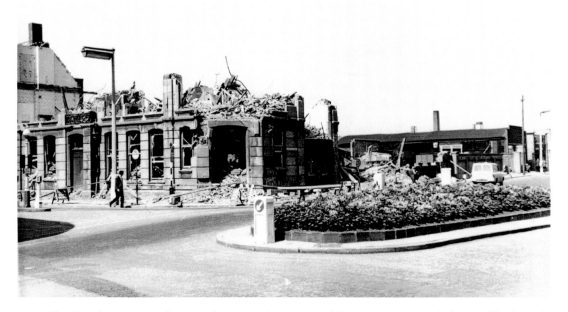

The Newdegate Arms has nearly gone when pictured here in August 1966 by Geoff Edmands during the final stages of demolition.

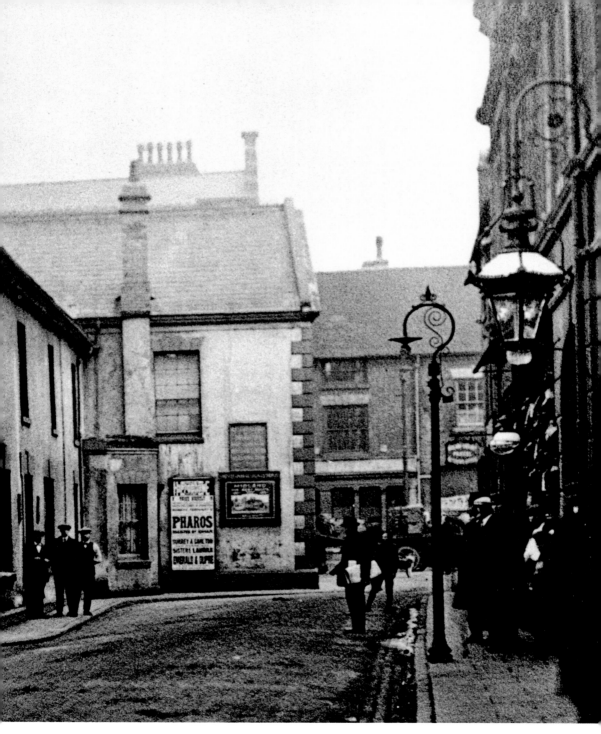

This was the problem with the old Newdegate Arms. It blocked the bottom of Abbey Street. By 1914 this had become a cause of congestion even though most of the traffic was horsedrawn. The owner, Mr 'Tuddy' Lilley, stands in the doorway. (Author's collection)

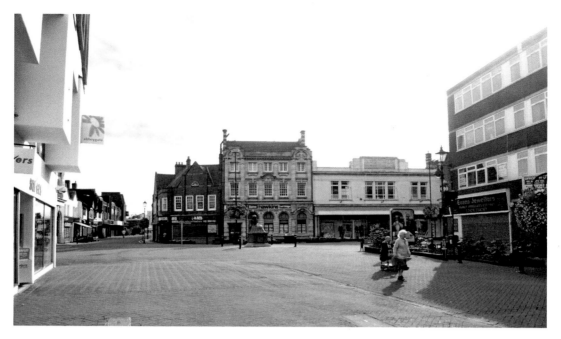

Newdigate Square today. The replacement Newdegate Arms has gone too.

Newdigate Square in the 1970s. The removal of the Newdegate Arms Hotel opened up the bottom of the street considerably. It's a shame the hotel that replaced the old one in 1914, also called the Newdegate Arms, was demolished in the 1960s. (Peter Bayly)

Oaston Road

If you look in the mid-nineteenth-century censuses and old parish records for Nuneaton you come across a curious name for a street: 'Odd-Aways Lane'. This is, in fact, Oaston Road. Oaston Road was part of the ancient route to Hinckley, which passed by the former mansion house known as Horestone Grange as it went over the fields towards Hinckley. The strange name 'Odd-Away' apparently refers to a former tenant or owner of the hall known as Horestone Grange. (Horestone, by the way, meaning grey-stone, as it was constructed from grey Attleborough freestone.) I cannot get to the bottom of who exactly 'Odd-Away' was. Some say it was Francis Stratford, last Lord of the Manor of that name (whose family descend through the Stratford Dugdales at Merevale today) who gave rise to the name; but other evidence says it was a tenant of Horestone Grange, which by then had been let as a woollen factory. The Stratfords had large woollen business interests, and after they vacated the Grange they rented it out to people they employed as woollen cloth weavers. By the mid-eighteenth century it is reported that Horestone Grange was a woollen mill, and the person who occupied and worked the equipment was 'odd'. Whoever that might be...

Horestone Grange burned down in mysterious circumstances in the mid-eighteenth century. No date has survived. However, its passing and the circumstances surrounding it gave rise to a well-known ghostly legend, and local people did not care to go near the ruins at night. It stood blackened, gaunt, abandoned and eerie across the fields from the top of 'Odd-Aways' Lane until the construction of the Nuneaton–Hinckley branch railway cut through it in 1860 leaving only odd fragments of out buildings and filled-in moats as evidence of where it formerly stood. By the 1860s the old name was no longer used and Oaston Road (a corruption of Horestone) was in common use.

The new railway to Hinckley was completed to Leicester in 1864, forming a physical barrier at the top of Oaston Road, the only roadway in Nuneaton blocked by two railway lines. In this case, however, the level crossing remained in use well into the 1970s, until the Leicester loop closed. The old level crossing now provides a route to the new housing estate known appropriately as Horestone Grange.

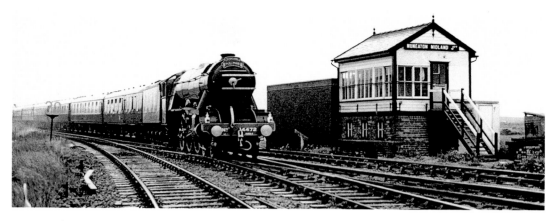

A photograph, taken in 1987 by the Revd David Hardy, of the famous ex-LNER engine *Flying Scotsman* threading Midland Junction and making its way along the loop line, which passed over the crossing seen in the following picture. The line to the right heads down to Nuneaton Trent Valley Station and is the line which is used today for all Leicester–Birmingham trains. Nuneaton Midland Junction box seen here was built on top of the former mansion house of Horestone Grange. The railway contractors cut a swathe through the remains of the old manor house in 1862 and the ancient stonework became rubble under this junction. This junction is gone; the box has been removed, but the *Flying Scotsman* still travels the country on steam specials.

Oaston Road level crossing when the loop line from Nuneaton Midland junction to Abbey Junction was in position with regular traffic. The track and the signal have been removed and parts of the trackbed have been turned over to other uses. Oaston Road was off to the right. When this photograph was taken there were only open fields to the left. The Horestone Grange housing estate had not been started. The reason the crossing was put in was to provide an ancient right of way, and access for farmers. Today the tracks have gone and the right of way is bordered by ugly palisade fencing. (Author's collection)

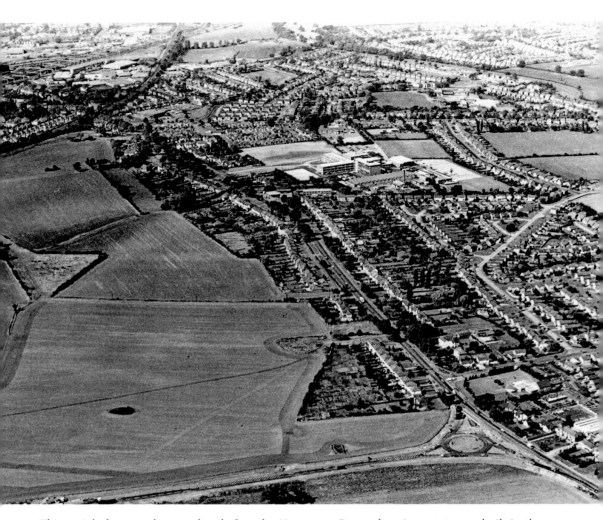

This aerial photograph was taken before the Horestone Grange housing estate was built in the great expanse of farmland on the left. Also to the left of the picture, a line of trees indicate a trackway that had once been the main road out of Nuneaton at the top of Oaston Road. The trackway has been obliterated by farming activity. To the right is Hinckley Road, and beyond that the St Nicholas housing estate.

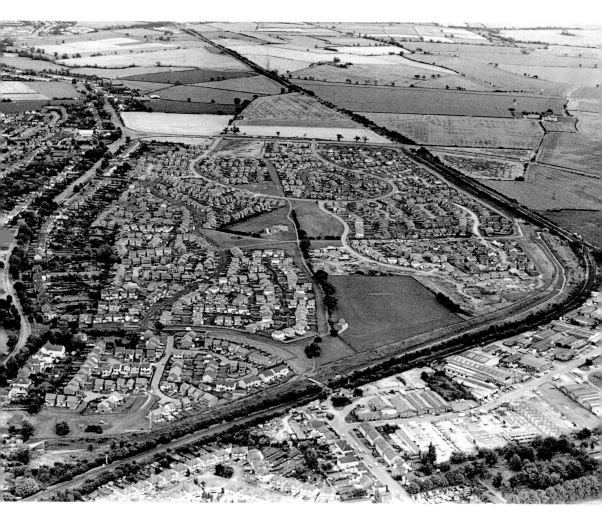

Taken from the opposite direction to the previous aerial view, the new and unfinished Horestone Grange housing estate has spread across the former open fields. The top of Oaston Road is in the bottom centre of the picture. The level crossing across the Leicester–Birmingham rail line is still in place at this point. Where the two railway lines meet on the extreme right of the picture was known as Midland Junction (shown previously with *Flying Scotsman* traversing the junction). This was the exact location of the old manor house of Nuneaton, Horestone Grange. Building the railway has almost completely destroyed the medieval site. The railway line ahead stretches towards Hinckley and ultimately Leicester.

Queen's Road/Wash Lane

Queen's Road today is one of Nuneaton's two principal streets, Abbey Street being the other. In the nineteenth century Queen's Road did not exist. There was a roadway there for sure, but in those days it was a country lane called Wash Lane. Water was the reason it was not built up. There were two streams running down it on both sides of the lane and occasionally when these were in full spate after a rainstorm the water level rose and met in the middle of the roadway; thus Wash Lane as it was all awash on a regular basis. Another interesting detail was that the border between Chilvers Coton parish and Nuneaton parish ran down Wash Lane, so one of these streams was in the former parish and the other in the latter. Neither side could agree whose responsibility it was to do something about the flooding problem. By the late nineteenth century pressure to provide building land for a burgeoning population meant that the local authorities had to take this issue seriously. Then the administration of both parishes merged, and it was decided that they needed to divert the flow so that the streams could be prevented from bursting their banks. The entire water output was transferred into a culvert that led to an outfall in the River Anker. The culverting was carried out around the year 1884. The culverting work solved the problem and paved the way for the road becoming built up. In the 1830s Nuneaton Gasworks had been established in Wash Lane and for a time it stood in splendid isolation on the outskirts of town. Then, around 1870, the town end of Wash Lane became Gas Street, whilst that beyond the gasworks Arbury Lane. In 1887 Queen Victoria celebrated her Jubilee and the part of Gas Street between Stratford Street and the Market Place was called Queen's Street to commemorate the occasion. From that day if you passed along Queen's Road you travelled through Queen's Street, Gas Lane and Arbury Lane before you got to the Cock & Bear Bridge. Then the confusion of names in Wash Lane was swept away and the whole roadway to the Cock & Bear canal bridge over the Coventry Canal was called Queen's Road. By that time the street had been properly culverted and buildings rose on either side as Queen's Road and the new streets beyond spread out into the countryside.

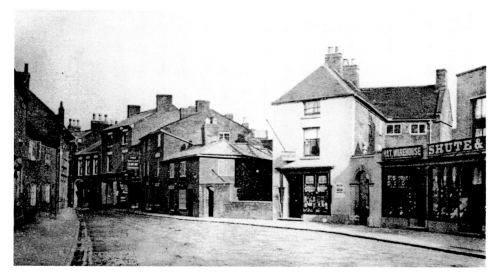

Queen's Road before it was known as such and possibly before this stretch was Queen's Street. It may have been Gas Street when this photograph was taken sometime in the 1880s or '90s. In the middle of the view is the wall of the bridge that provided an outlet from the culvert that flowed down Queen's Road at this point. The Wash Brook flows openly from here prior to its entering the River Anker in Mill Walk. The pub sign for the old Red Lion public house is visible. This pub was replaced some time around the turn of the century. Shute & Son was a gent's outfitters business in Nuneaton established in 1824. (Author's collection)

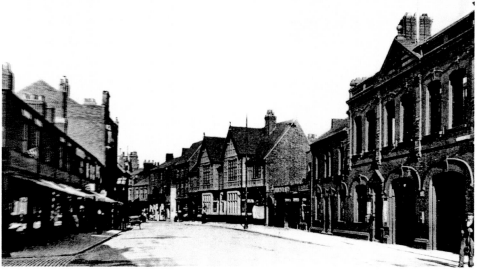

Many local people will recall how Queen's Road looked before wholesale demolition in the '60s and '70s destroyed the buildings on the right. The twin-gabled pub was the Red Lion and to its right the former council offices and fire station, which was later used as a library after the town hall was completed in the 1930s. (Author's collection)

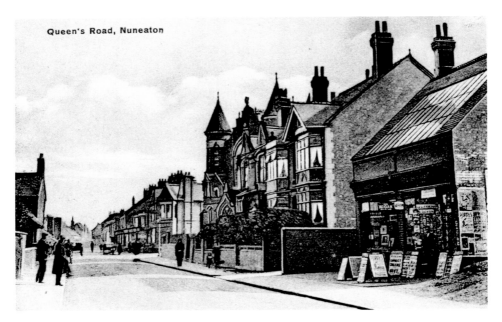

Queen's Road, Nuneaton

Queen's Road sometime around the First World War. The conical turrets of the former Primitive Methodist chapel, with its magnificent rose glass window, are prominent in the centre. Just beyond, Edward Street is off to the right. On the opposite corner Nuneatonians will remember Porter's, the ironmonger's, although in earlier times when this photograph was taken it was the Alderney Dairy; the Porter family's first business there. The large glass roof-light windows over the shop on the right indicate the photographic studios of E. V. Openshaw, which occupied the left half of the building. On the right in later years was Haynes' paper shop. (Author's collection)

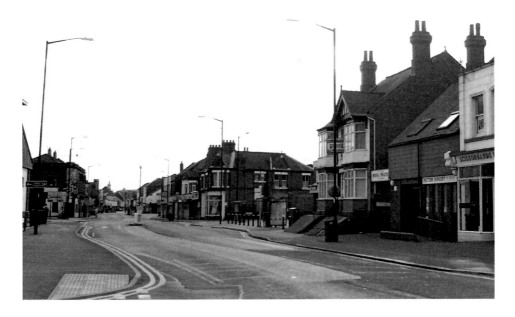

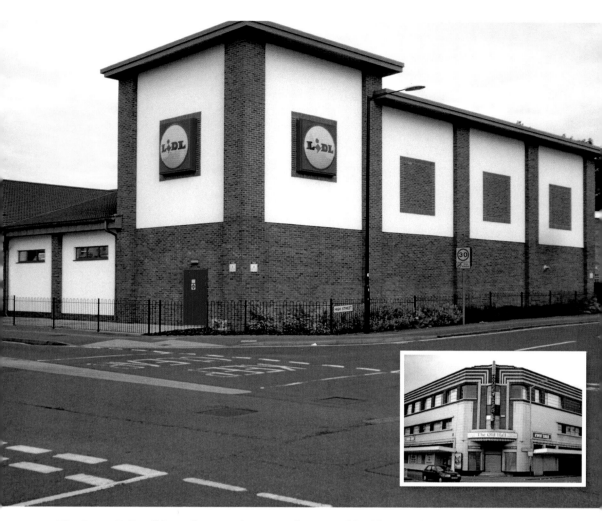

The Co-op Hall will be sadly missed. It was a fine period building, and when opened in February 1939 provided state-of-the-art ballroom facilities for the people of Nuneaton. For many local people it provided fond memories of romance and pleasure on Friday and Saturday nights. The Lidl store that replaced it does not capture the style and sense of dignity of the old hall. Like so many of Nuneaton's modern buildings captured in this book, its boxy exterior is bland and unimaginative (inset).

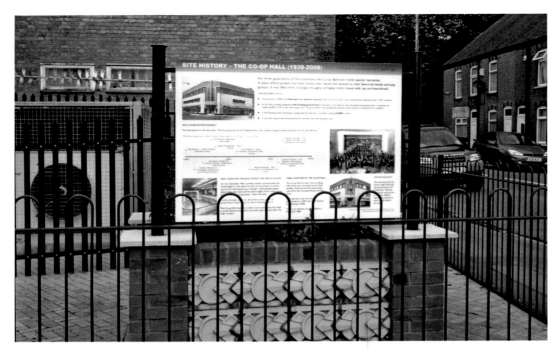

Lidl, the new site owners, did, however, commission a Heritage Board to give a brief history of the site, which incorporates some of the original terracotta work.

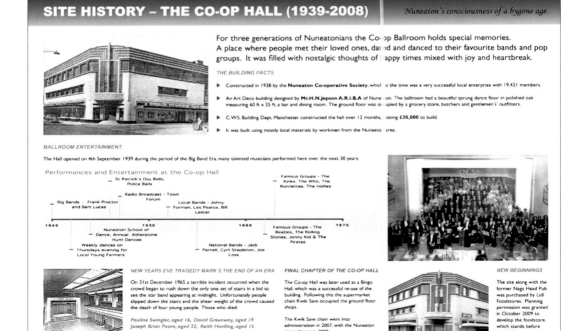

SITE HISTORY – THE CO-OP HALL (1939-2008)

Nuneaton's consciousness of a bygone age.

For three generations of Nuneatonians the Co-op Ballroom holds special memories. A place where people met their loved ones, danced and danced to their favourite bands and pop groups. It was filled with nostalgic thoughts of happy times mixed with joy and heartbreak.

THE BUILDING FACTS

▶ Constructed in 1938 by the **Nuneaton Co-operative Society**, which at the time was a very successful local enterprise with 19,421 members.

▶ An Art Deco building designed by **Mr.H.N.Jepson A.R.I.B.A** of Nuneaton. The ballroom had a beautiful sprung dance floor in polished oak measuring 60 ft x 25 ft, a bar and dining room. The ground floor was occupied by a grocery store, butchers and gentlemen's' outfitters.

▶ C.W.S. Building Dept. Manchester constructed the hall over 12 months, costing **£30,000** to build.

▶ It was built using mostly local materials by workmen from the Nuneaton area.

BALLROOM ENTERTAINMENT

The Hall opened on 4th September 1939 during the period of the Big Band Era, many talented musicians performed here over the next 30 years.

Performances and Entertainment at the Co-op Hall

1940	1950	1960	1970

Big Bands - Frank Proctor and Bert Lucas
Radio Broadcast - Town Forum
St Patrick's Day Balls, Police Balls
Local Bands - Johny Forman, Les Pearce, Bill Lester
Famous Groups - The Kinks, The Who, The Ronnettes, The Hollies
Nuneaton School of Dance, Annual Atherstone Hunt Dances
Weekly dances on Thursdays evening for Local Young Farmers
National Bands - Jack Parnell, Cyril Stapleton, Joe Loss
Famous Groups - The Beatles, The Rolling Stones, Jonny Kid & The Pirates

NEW YEARS EVE TRAGEDY MARKS THE END OF AN ERA

On 31st December 1965 a terrible incident occurred when the crowd began to rush down the only one set of stairs in a bid to see the star band appearing at midnight. Unfortunately people slipped down the stairs and the sheer weight of the crowd caused the death of four young people. Those who died:

*Pauline Swingler, aged 16, David Greenway, aged 19
Joseph Brian Peore, aged 22, Keith Harding, aged 15*

The Co-op Hall closed for a while to carry out repairs and install a second staircase, however it was never quite the same after the tragic incident.

FINAL CHAPTER OF THE CO-OP HALL

The Co-op Hall was later used as a Bingo Hall, which was a successful re-use of the building. Following this the supermarket chain Kwik Save occupied the ground floor shops.

The Kwik Save chain went into administration in 2007, with the Nuneaton store closing in 2008.

The Co-op Hall then was demolished in November 2008.

NEW BEGINNINGS

The site along with the former Nags Head Pub was purchased by Lidl Foodstores. Planning permission was granted in October 2009 to develop the foodstore, which stands before you today.

*In Memory of Pauline Swingler, Joseph Peore, Keith Harding and David Greenway
Information provided by Peter Lee of the Nuneaton Society.*

Queen's Road in the 1960s or very early '70s. By this time the remains of the former gasworks buildings still stood in the extreme left background. I wonder where those fair ladies striding so purposefully across this busy road are today. Remember Van Allan, where ladies purchased the finest outfits? All has now been pedestrianised. (Maurice Billington)

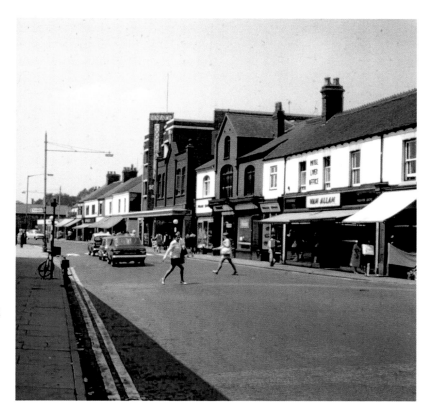

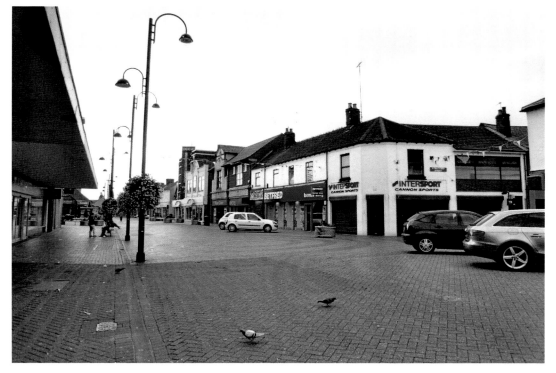

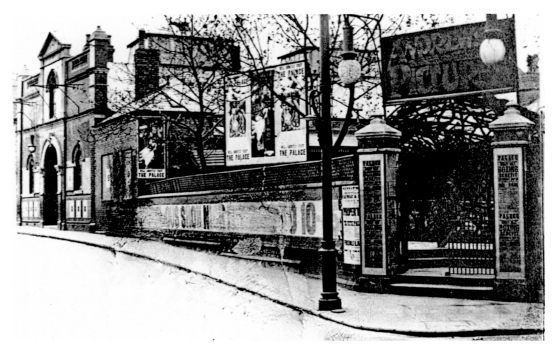

Locals today might be hard pressed to recognise this spot. Eventually the gateway and garden walls would be swept away when this became the site of the Palace cinema. At the time this photograph was taken the building on the left was Andrew's Picture Palace in Victoria Street. The gardens behind the gate were the Palace Gardens lit with fairy lights hidden amongst the trees. The old Palace Gardens lie buried beneath Nuneaton's inner ring road. (Author's collection)

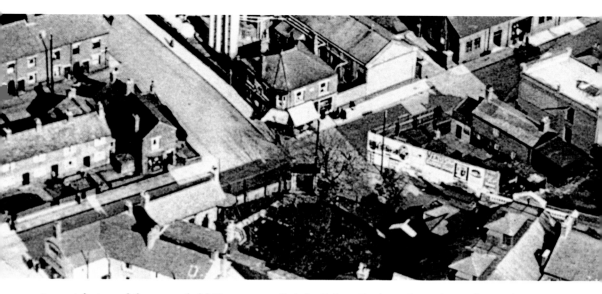

An aerial view of the spot of old Nuneaton called the Palace Gardens. Queen's Road is in the centre and Broad Street leads off the top of the picture. The photograph was taken in the mid-1920s. The small garden is in the bottom-centre of the picture and to its right was Andrew's Picture Palace. The former Picture Palace became a skating rink after the opening of the new Palace cinema on the site of the former Palace Gardens, and was gutted by fire in the early '70s. (Author's collection)

Stratford Street

Stratford Street took its name from the Stratford family who owned the manor of Nuneaton for well over 100 years. They were, in fact, the second-wealthiest family in England, with estates stretching from Stow-on-the-Wold in the Cotswolds to Tewkesbury. They grew tobacco and traded in wool. They had large estates in Ireland and business interests in Germany. In the first part of the seventeenth century they gradually acquired land in Warwickshire. They purchased Horestone Grange, purchasing more land in Nuneaton including the former Abbot's house – the Habit – on the perimeter of Nuneaton Market Place. Stratford Street was laid through its gardens. Stratford Street provided a cut through from Abbey Street to what was then Wash Lane. One of its earliest residents was William Smith, a local builder and undertaker (still trading today at Attleborough).

Weddington Lane

The town end of Weddington Lane was called Derby Lane, as it eventually led to Derby, but once you got into the country it was a roadway leading to Weddington, and so was appropriately known as Weddington Lane. In those days there were no houses and up until around 1920 only 100-odd souls lived in Weddington. After 1930 it became rapidly built up as a suburb of Nuneaton.

Wheat Street

I mentioned earlier that Wheat Street up until the eighteenth century had been the way out of town towards Hinckley. The realignment of this main road around 1735 reduced Wheat Street's importance and then the construction of the Trent Valley Railway ran across at the top. At first the road alignment was preserved by providing a level crossing, and a tunnel under the track was provided for pedestrians. The level crossing created additional operating difficulties for the railway company at the south end of the station as they had two sets of level crossings in close proximity to each other. When Leicester Road Bridge was erected in the 1870s the level crossing was dispensed with. Wheat Street was blocked up leaving just the tunnel for foot traffic more or less as today. This tunnel led to Oaston Road.

Another small detail was that there used to be a trackway with an iron fence that led away from the top of Wheat Street alongside the railway to the loco shed. This was called the Birdcage by generations of footplate staff going to work. When the line was electrified in 1962/3 and gantries erected for the overhead wiring, the concrete bases of the gantries impinged on this cinder path, so it was closed. The cast-iron railings were simply moved back to the fence line of the houses in Glebe Road and were still there a few years ago, and may still be but the fence line has become thoroughly overgrown.

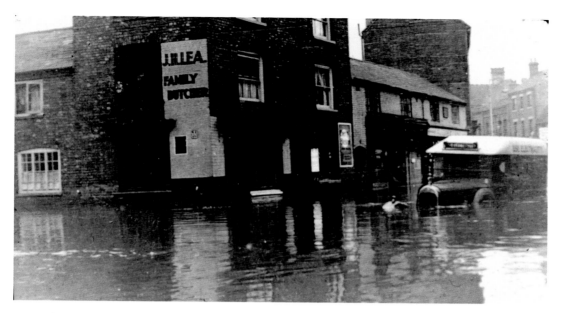

The corner of Wheat Street and Church Street during the great flood of 1932 serves to illustrate the great depth of water reached which has disabled the van. The ingress of filthy river water must have devastated Mr J. H. Lea's butchery business. (Author's collection)

The Albion buildings look gaunt and decrepit in this old view, but were once a hive of industry. From these buildings a man set out to America, Joseph Warner (1855–1925), who was a foreman at George Leake's ribbon factory, and opened what was to become the largest woven silk manufacturer in the USA at Paterson, New Jersey: the Warner Label Co. The Albion buildings also housed another company, A. W. Phillips (established c. 1883), who made tennis balls, footballs, rugger balls, and net balls. They produced 100,000 tennis balls a year, 50 per cent of which were exported to the USA. They made balls for Wimbledon and all of the big tennis tournaments.

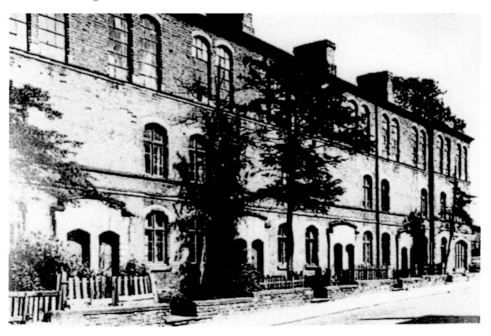

Attleborough Church

Attleborough church and the vicarage in 1864 (following page). You would hardly recognise this aspect today, although both buildings are still there. The shrubbery in the foreground has grown into mature trees and changed so completely as to mask out the view. Both structures now can only be seen by peering through the boscage. Here it is all new and fresh and beautifully laid out. The buildings were erected on a portion of the former grounds of Attleborough Hall. After the death of George Greenway (1761–1835), who owned and completed the hall in 1809, the estate was managed by his son-in-law, John Craddock. John Craddock lived at Attleborough Hall for a few years before he had a house built on Camp Hill – Camp Hill Hall – in 1838, which was paid for by a legacy from his father, William Craddock, banker and merchant, who died in 1833. He was the richest man in Nuneaton and left £120,000 in his will, which was a considerable fortune in those days. The Attleborough Hall estate sold a piece of land for a new chapel of ease at Attleborough in 1842; this became its parish church in due course. The new church was erected at a cost of £3,000. The structure was mostly of brick with the tower and spire in Attleborough freestone. The living of Attleborough church was a perpetual curacy in the patronage of the Vicar of Nuneaton. The new church was to provide some modicum of Godliness to the labouring classes of the hamlet of Attleborough, which was then somewhat remote from the town of Nuneaton. Most Attleboroughians did not bother to attend church, which comprised a mile-long walk into town.

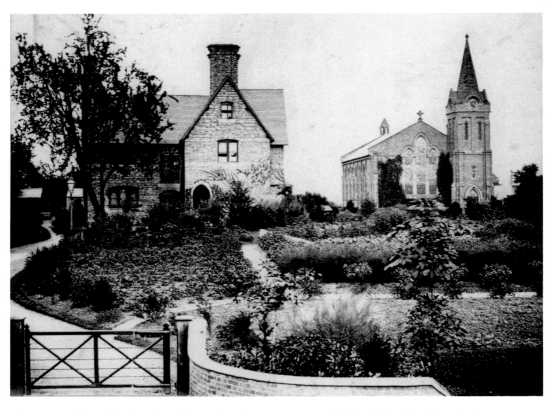

The approach to the church today is largely overgrown, with both the church and vicarage hidden by the foliage.

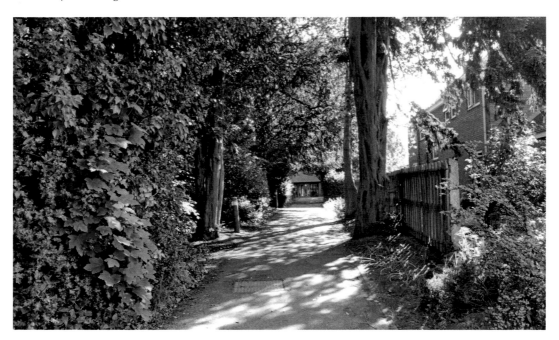

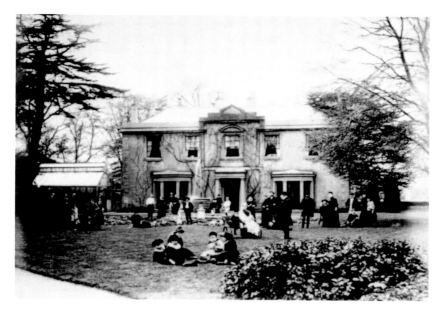

It is impossible to obtain a view of Attleborough Hall in the same location today, but I have put this photograph in to illustrate local life in 1885, when this picture was taken to mark the fiftieth wedding anniversary of Thomas and Sarah Townsend, surrounded by their extended family. Sarah is sitting in the centre of the picture with her white shawl and Thomas is to her right looking towards her. (Courtesy of Jan Brock)

Another view of the 1885 anniversary and a different aspect of the house. Thomas and Sarah Townsend pose in the foreground with their family around them (Thomas to the left and Sarah, with white shawl, to the right). It looks as though the photographer has removed his top clothing and hung it on the fence in order to obtain his picture. Beyond the house is a large greenhouse and beyond that the Attleborough vicarage can just be glimpsed through the trees. (Courtesy of Jan Brock)

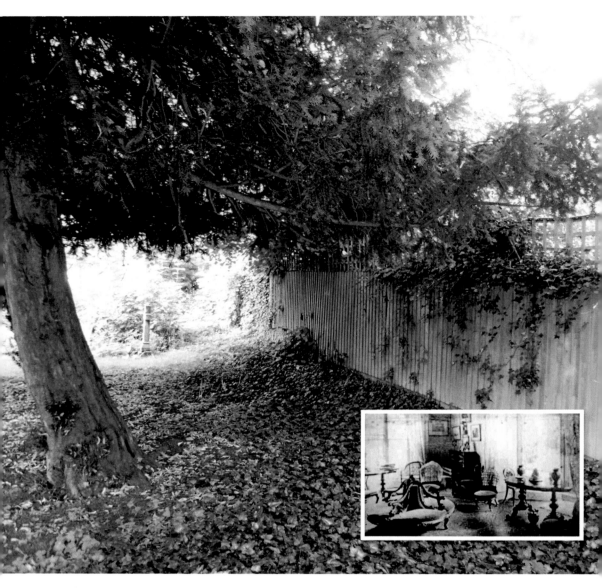

This is the view today of the perimeter of Attleborough Hall gardens as it backs on to Attleborough churchyard. The gardens themselves are swallowed up by the domestic garden plots of the post-1930s houses over the wall, which replaced the pleasure grounds laid out so tastefully in the nineteenth century.

Inset: Inside the drawing room at Attleborough Hall, which was full of expensive and elaborate Victorian furniture and pottery. The year is 1890. (Courtesy of Jan Brock)

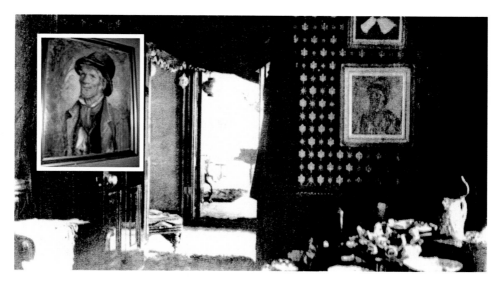

This is the dining room in 1890. The oil painting on the wall survives in a house in Napier, New Zealand, and is lovingly looked after by Jan Brock, a descendant of the Townsends who lived there. William would have found it unbelievable that his memory lives on so far away from the native Attleborough he probably hardly ever left.

Inset: The figure in the portrait by Pattie Townsend is William Garratt (1827–98), a faithful retainer of the Townsends. Just peeping out below the brim of his hat is a red handkerchief. He wrapped his lunch in this red handkerchief and stored it in his hat! This painting of William featured on the *Antiques Roadshow* some years ago and that was how Jan managed to obtain it. (Courtesy of Jan Brock)

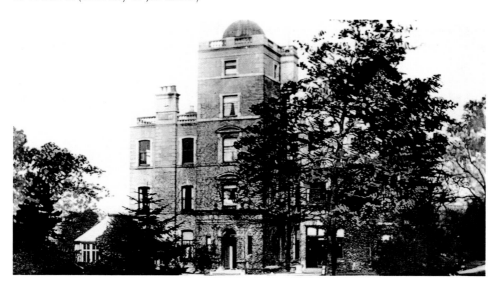

After Thomas Townsend died his daughter Pattie, the talented artist, married Joseph Fielding Johnson, who moved in with her at Attleborough Hall. The Fielding Johnsons had an observatory fitted, as one of Mr Fielding Johnson's sons was keen on astronomy. This view is impossible today as a housing estate was built over the house and its grounds. (Author's collection)

Attleborough

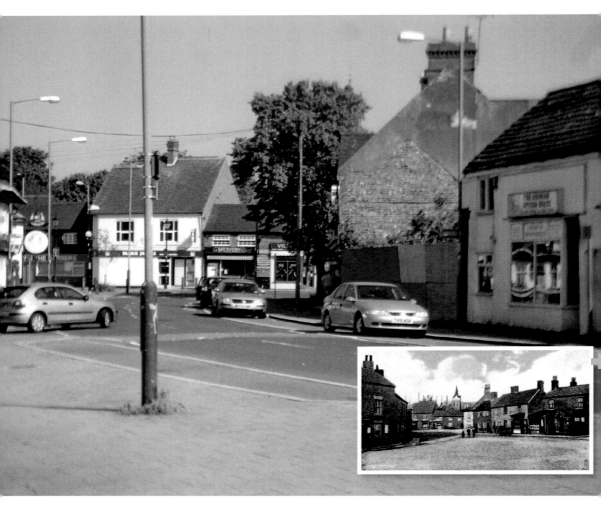

An old picture postcard of Attleborough Green (inset), looking towards the square with the church in the background, c. 1900. The cream frontage of the Royal Oak peeps out from behind the three youngsters standing in the roadway. (Courtesy Jean Lapworth)

Chilvers Coton

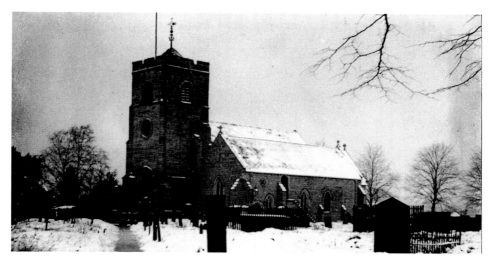

Chilvers Coton church, c. 1909, on a very cold and wintry day. The old church was burnt by incendiary bombs in May 1941 and the body of the church we see here entirely rebuilt after the war. (Thomas C. Neath)

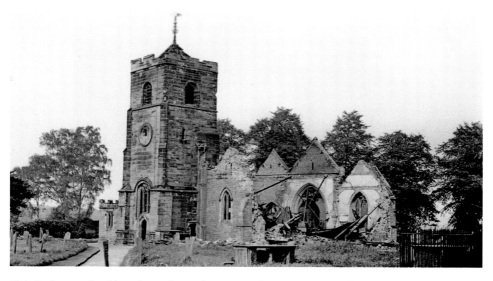

This is the result of bombing that infamous night in May 1941 when the Luftwaffe carried out a major raid on Nuneaton. Their target was the railway line but bombing in those days was a very hit-and-miss affair and they mostly missed the tracks and peppered either side. Incendiary bombs clattered on to the roof of Coton church. The fire took hold and the roof collapsed. The flames gutted the church. The tomb, with its sides gaping open as a result of blast damage, was that of George Eliot's father, Robert Evans. (Geoff Edmands collection)

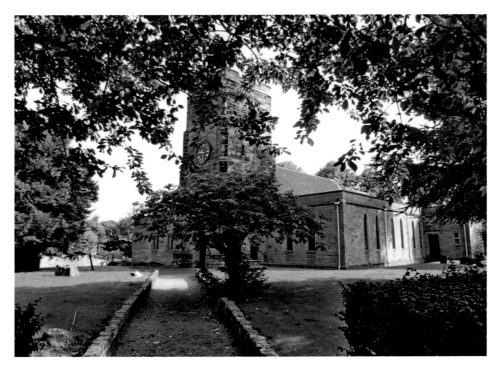

The church as it is today. Robert Evans' grave is hidden by the tree in the foreground, and has been entirely repaired.

Although Coton church was restored after the war, the old galleries could not be put back as they did not meet modern building regulations, so the rebuilt church took on a more modern look. The statue of Christ on the right below was an appropriate contribution to the churchyard. (Author's collection)

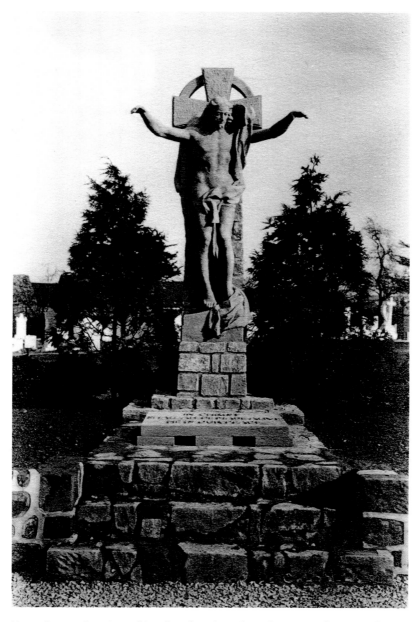

Near Coton church within the churchyard is this magnificent sculpture rendered in concrete over a mesh netting framework, which was crafted by one of the German prisoners of war – a native of Munich – Karl Weber. He was an expert sculptor and this rendition of Christ risen from the cross serves to remind us of the reconciliation between Germany and Britain after the war, and the excellent work carried out by prisoners of war at Arbury Camp in the reconstruction of the bombed Chilvers Coton church. (Geoff Edmands collection)

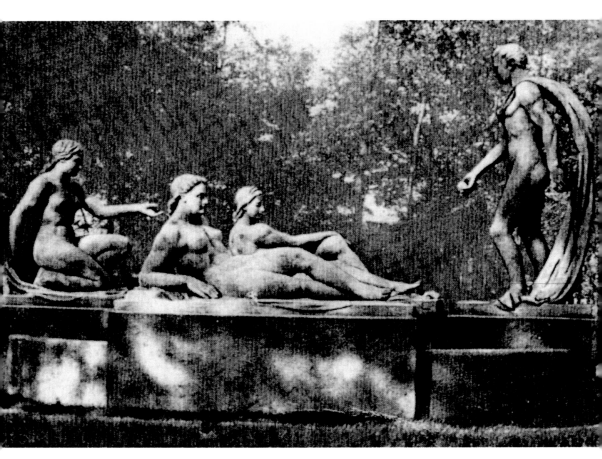

The German prisoner of war sculptor Karl Weber created another sculptural work known as the *Four Graces*, which had a rather risqué character to it. Perhaps this was the reason it stayed unseen in the former army camp, turned into a prisoner of war camp, on the Arbury estate. Eventually it disappeared and I know that some research was carried out to try to find its whereabouts a few years ago. I was told by someone years ago that it was taken away by lorry to an address in Coventry, but no one has ever come forward with news of its present location, or if indeed it survives. (Mollie Knight collection)

One of the old Chilvers Coton bells, which dated back to 1616, was melted down in 1907. It was cast the very year that William Shakespeare passed away. It bore the inscription 'God Save the King'. (Author's collection)

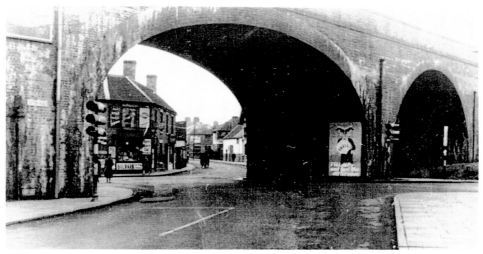

Coton Arches is an iconic Nuneaton landmark today, but the setting has changed a lot since this view was taken in the 1950s. Daulman's paper shop peeps under the great shallow arch, which expressed the confidence of our Victorian railway engineers when this structure was first erected. It was so wide and shallow that when it was first built local people intimated concern that it might not stand the weight of trains going across it. This was at the time of some pretty spectacular railway bridge collapses, including two on this line alone: one at Bedworth and another when Spon End Arches collapsed in Coventry in the late 1850s. This was all around the time the central arch here was erected. It is thought that the Arches is in fact the second bridge on the site; the first one, built of cast iron, was dismantled as there had been a number of cast-iron bridge collapses in this decade. At any rate the bridge has stood the test of time and still carries regular heavy container trains trundling along to Birmingham from Southampton docks, or petrol tankers to sidings in Bedworth. The modern-day view of the same location can only be seen from the centre of a large traffic island.

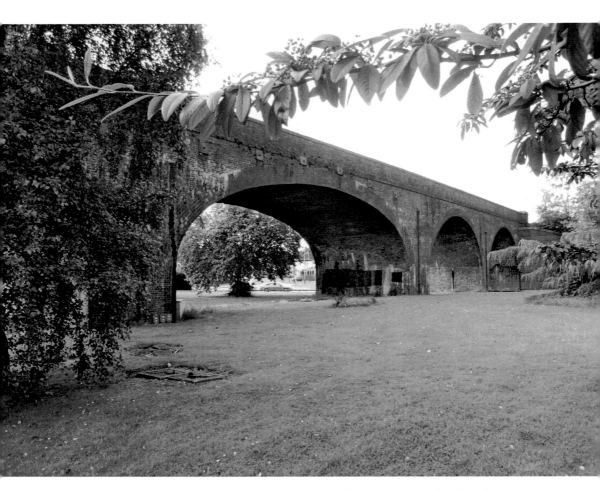

An unusual view of Coton Arches by Geoff Edmands, which was taken on a bleak and wintry 17 February 1968 from the top of the clock tower of Chilvers Coton church. The Fleur de Lys pub is the prominent white-painted building left of centre. The railway arches can clearly be seen, with Avenue Road to the right. Chilvers Coton parish is beyond. Standing high above the horizon is Courtaulds mill.

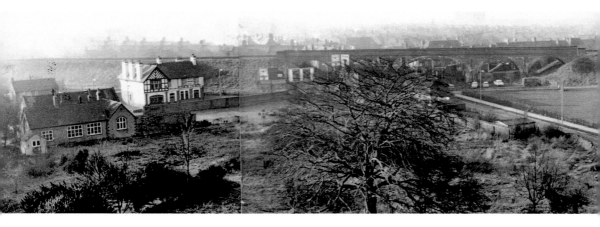

Chilvers Coton Foundry still stands today, but its survival is a miracle. The local authority had no hesitation to pull it down when a demolition proposal was put forward. However, a quiet word in someone's eminent ear led to its reprieve. This is the result. Conservation of old buildings pays off in the end. (Author's collection)

Stockingford

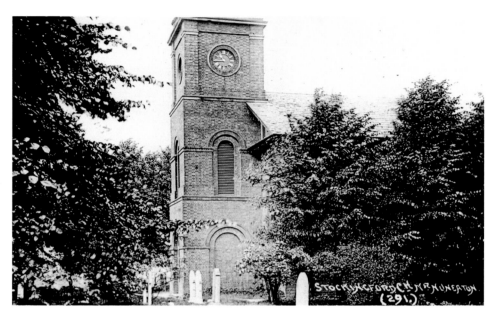

Stockingford church was opened in 1824 as a chapel of ease for Nuneaton Common. It features in George Eliot's first set of stories, *Scenes of Clerical Life*, a series of novellas set in the Nuneaton area. Stockingford church was the church on Paddiford Common in *Scenes*. This view was taken around 1905. The real excitement of Stockingford's chapel of ease in the early days was generated by the Revd John Edmund Jones (Revd Edgar Tryan in *Scenes of Clerical Life*). Revd Jones was curate in charge from 1828–31. His sermons were very popular with the labouring people of the area, who like a bit of fire in their religion. (Author's collection)

Weddington

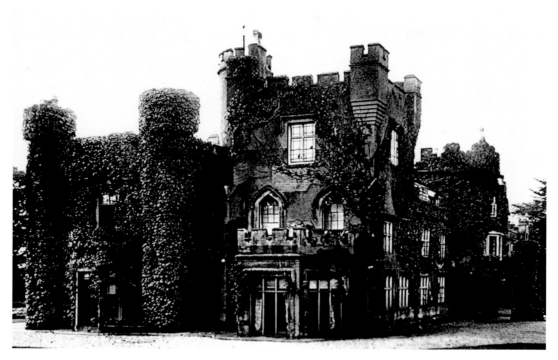

Weddington Hall stood on the green void in Castle Road. Weddington Hall was often wrongly referred to as a castle, although it never had this status, only being castellated in the fashion of similar country houses erected at the beginning of the nineteenth century (1807/8) by its new owner Lionel Place to the designs of his architect Robert Lugar (1773–1855). The estate formerly covered 350 acres. It was one of five country estates (Camp Hill Hall, Haunchwood House, Attleborough Hall, and Lindley Hall) demolished in the 1920s and 1930s in the local area. The hall stood on the green space in Castle Road. The view overleaf is approximately the same viewpoint today. (Author's collection)

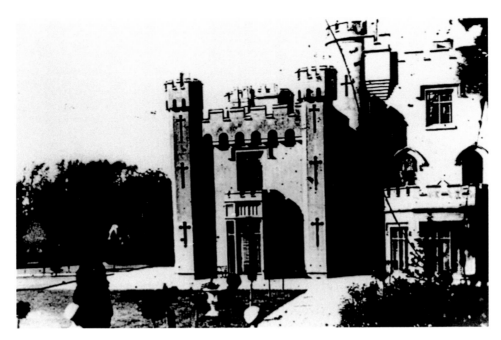

This lovely old country seat was cleared away in the 1920s, but traces of it can still be seen in Weddington if you know where to look, and there is a website dedicated to it.

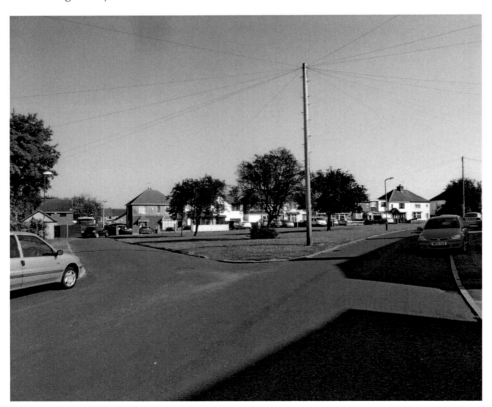

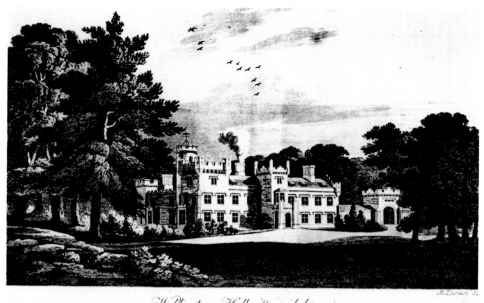

Weddington Hall, Warwickshire.

London: Published by J. Taylor at High Holborn

An artist's rendition of the mansion as first constructed at the beginning of the nineteenth century.

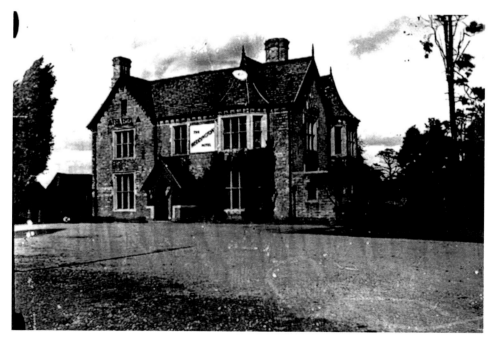

The Weddington Hotel, more popularly known as the Grove, was originally a large family house associated with the Weddington Hall estate. (Author's collection)

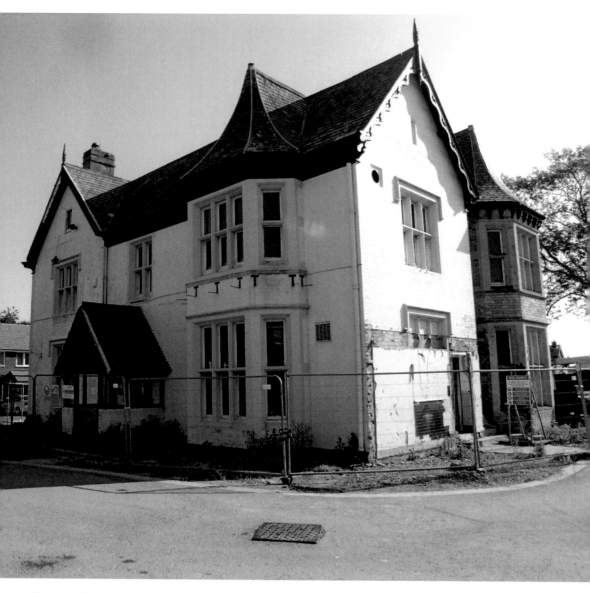

The Weddington Hotel is now scheduled to be turned into flats, but currently stands dilapidated amongst an estate of new houses, which filled up its spacious gardens.

The Author

Peter Lee is a well-known local historian in Nuneaton. He is chairman of the Nuneaton Civic Society, founder of the Nuneaton Local History Group and the Nuneaton & North Warwickshire Family History Society, as well as being involved in many projects to raise public awareness in local heritage and the built environment. He says, 'From my first early schooldays I seemed to have empathy for the town I was born into. My legacy is to share my interests with others and publish information in the hope of raising their interest in the future. I have been fortunate to know many old townsfolk who were very knowledgeable in many different ways and who shared this knowledge with me. I feel the need to pass it on to future generations. It is no good resting in a private collection. My old friends and correspondents are nearly all dead and without me their memories and interests will be forgotten forever.'

Peter Lee writes a weekly local history column for the *Nuneaton News*, and has contributed hundreds of articles for local papers, specialist magazines, newsletters, on the internet, and other publications. He is also the author of nine other local books:

The Coventry & Nuneaton Railway, co-authored with Mike Musson (*Bedworth Echo*, 1982).
A History of Brewing in Warwickshire, co-authored with Fred Luckett and Ken Flint (CAMRA, 1983).
The Trent Valley Railway (Trent Valley Publications, 1988).
Images of England, Nuneaton (Tempus Publishing, 2000).
Images of England, Nuneaton, Volume II (Tempus Publishing, 2004).
Railways of Nuneaton & Bedworth (Tempus Publishing, 2005).
Nuneaton Revisited (Tempus Publishing, 2006).
Nuneaton Through Time (Amberley, 2009).
Nuneaton & Bedworth Coal, Stone, Clay & Iron (Amberley Publications, 2011).